PRE -RAPHAELITE BIRMINGHAM

by Roy Hartnell

– For Joy –

PRE -RAPHAELITE BIRMINGHAM

by Roy Hartnell

First published in 1996 by Brewin Books, Studley, Warwickshire

Front cover: The Cathedral Church of Saint Philip. Birmingham. Stained glass window designed by Edward Burne-Jones 1833-1898 and made by Morris and Company 'The Last Judgement' 1898 – DETAIL

Back cover: 'The Last of England' 1852-1855 Ford Madox Brown 1821-1893. Exhibited in the Exhibition of Pre-Raphaelite Art and Birmingham Municipal Art Gallery 1891, purchased by the Gallery in 1891.

ISBN Hardback 1 85858 079 X
ISBN Paperback 1 85858 064 I

Typeset in Palatino and made and printed in Great Britain
by Warwick Printing Co. Ltd., Warwick, Warwickshire

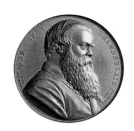

*Chamberlain Medal
for Design 1886
by Joseph Moore*

CONTENTS

Page

Acknowledgements vi

List of Illustrations vii

Foreword by Peter Berry viii

INTRODUCTION – Birmingham – "the most artistic town
in England" ? 1

CHAPTER 1 – Art in Birmingham 1800-1850 7

CHAPTER 2 – Pre-Raphaelitism in Birmingham 28

CHAPTER 3 – Pre-Raphaelitism and the Civic Gospel 50

CHAPTER 4 – William Morris and Edward Burne-Jones in
Birmingham 70

CHAPTER 5 – Birmingham Pre-Raphaelites 95

CHAPTER 6 – Pre-Raphaelite Birmingham Today 115

Select Bibliography 118

Sources 120

Index 121

ACKNOWLEDGEMENTS

Any researcher into the history of Birmingham must first acknowledge the importance of the comprehensive holdings of the Birmingham Reference Library, especially the Local Studies Collection, and the co-operation of Patrick Baird and his staff.

I have received information and encouragement from many individuals, but I particularly wish to thank Dorothea Abbott, Paul Aston, Dr B.S.Benedikz, Ernest Biddle, Anthony Blakemore, Hans Brill, Lord Asa Briggs, Jessie Cook, Professor Christopher Cornford, Alan Crawford, Dr Elton Eckstrand, Graham Foster, Professor Christopher Frayling, Charlotte Gere, Dr Lucy-Anne Hunt, Edward Hollamby, Joe Holyoak, Alexander Jackson, Anne Kenrick, Richard Lockett, Dr Jan Marsh, Professor Bernard Myers, Dr Stana Nenadic,Dorothy Priddey, Dr John Seed, Tessa Sidey, Peyton Skipwith, Dr Roy Sladden, David Temperley, Dr Chris Upton, Glennys Wild, Stephen Wildman, George Williams and Peter Williams, for their help.

I owe a special debt to Professor John Swift for many stimulating conversations and access to the archives of the Birmingham Municipal School of Art.

I appreciate the enthusiastic support of the Very Reverend Peter Berry, Provost of Birmingham Cathedral and founding-Chairman of the Pre-Raphaelite Society.

I am grateful for help received from the following, all of whom are now dead; the 8th Earl Beauchamp, for permitting me to see the Chapel at Madresfield and for sharing memories of the Birmingham Group with me in Ashbee's library despite serious illness; Dr A.R.Dufty, for sharing insights into William Morris in a memorable conversation in the kitchen at Kelmscott Manor; Robert Ferneyhough, for access to his collection of Tayloriana and Ruskin pottery; Charles Handley-Read, who first introduced a young schoolboy to the Pre-Raphaelites when they were very unfashionable; Douglas Hickman, for sharing his love of Birmingham buildings; John Kenrick, who answered many questions and allowed me to quote from Cecily Debenham's unpublished RECOLLECTIONS; Edward Payne, for considerable correspondence and hospitality; and the following former Birmingham School of Art students – William Bloye, Barbara Bridgwater, Gilbert Francis and Cyril Lavenstein.

I am grateful to the Committee of the Guild of Saint George for awarding me a John Ruskin Research Grant.

The photography was undertaken by Jonathan Hartnell except for the colour studies of the Burne-Jones windows in Birmingham Cathedral for which I must thank Alastair Carew-Cox.

Finally, I must thank my wife for her constant support and forbearance through the long hours of research and writing.

LIST OF ILLUSTRATIONS

Page

OBC 'The Last of England' 1852-5 by Ford Madox Brown.

v. Chamberlain Medal for Design 1886 by Joseph Moore.

1. Chamberlain Place, Birmingham 1887.

13. 'View from the Dome of St.Philip's' 1821 by Samuel Lines.

15. Interior of the Panorama 1830.

18. The Birmingham Society of Artists Gallery 1829.

20. Interior of the Gallery 1829.

29. 'The Two Gentlemen of Verona' 1851 by Holman Hunt.

30. Interior of St.Chad's Cathedral 1839 by A.W.N.Pugin.

32. Gas Fittings 1849 by William Aitken.

34. The Hardman Stand, Birmingham Exhibition 1849.

35. The Birmingham and Midland Institute 1854 by E.M.Barry.

44. Shenstone House 1858 by J.H.Chamberlain.

62. Anteroom in The Grove 1877 by J.H.Chamberlain.

63. Highbury 1879 by J.H.Chamberlain.

64. Highbury – interior.

68. "'Time moveth not, our being 'tis that moves'" 1883 by Walter Langley.

75-77. Birmingham Municipal School of Art 1883 by J.H.Chamberlain.

80-83. Stained glass windows in the Cathedral Church of St.Philip 1878-1898 by Edward Burne-Jones and William Morris.

84. 'The Star of Bethlehem' 1889 by Edward Burne-Jones.

88. 'The Blind Girl' 1854-56 by John Everett Millais.

91. 'Kelmscott Manor' 1892 by Charles Gere.

93. Class at Municipal School of Art 1900.

98. 'Melody' 1895 by Kate Bunce.

99. 'A Reverie' 1897 by Edward Samuel Harper.

100. Illustration 1893 by Mary Newill

105. Illustrations 1903 by Joseph Southall, Edmund New, Arthur Gaskin and Violet Holden.

106. 'The Enchanted Sea' 1900 by henry Payne.

107. 'Self-Portrait' 1901 by Maxwell Armfield.

109 Beauchamp Chapel 1902-23 Madresfield Court.

113 'Corporation Street Birmingham in March 1914' 1916 by Joseph Southall.

FOREWORD

Birmingham Cathedral
From the Provost The Very Reverend Peter Berry MA

13 May 1996

Dear Dr. Hartnell,

I am delighted to commend your marvellous book on the Pre-Raphaelites in Birmingham.

As the Provost of the Cathedral Church, I have a daily encounter with the works of Edward Burne-Jones and his own subtle interplay of line and colour and movement and the compression and elongation of form.

The Pre-Raphaelites brought a new reality into artistic perception, and at the same time combined a new romanticism in the use of historic themes. It is marvellous to think that at the end of the 20th century we have reinstated the Pre-Raphaelite vision as one of the authentic visions of artistic truth.

For Birmingham to be a place where the collection of Pre-Raphaelite paintings and drawings has high prominence is in itself a remarkable achievement, and I know your book will be read with great interest.

I send my regards and good wishes.

Yours sincerely,

Chairman of the
Pre-Raphaelite Society

Birmingham Cathedral, Colmore Row, Birmingham B3 2QB
Telephone: 0121-236 4333 and 0121-236 6323 Fax: 0121-212 0868

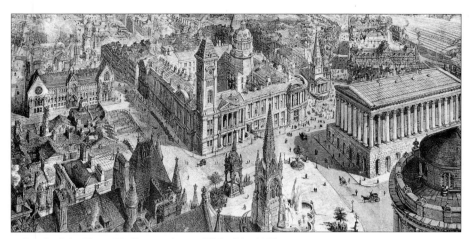

.Chamberlain Place. Bird's-eye view published in 1887.

Left centre: Municipal School of Art, Centre: Municipal Art Gallery – portico and clock tower, and Council House dome. Top centre: the baroque dome of St.Philip's. Centre right: Christ Church. To its right, the entrance to the Royal Birmingham Society of Artists Gallery, New Street, can just be seen.

Right centre: the pillared Town Hall. Right bottom: the Edmund Street facade to the Reference Library. Centre bottom: the monuments to George Dawson and Joseph Chamberlain. Left bottom: the turreted roof of Mason College.

INTRODUCTION

BIRMINGHAM – "THE MOST ARTISTIC TOWN IN ENGLAND" ?

At the end of the 1880's, two journalists visiting Birmingham were impressed by what they found.

Julian Ralph from HARPER'S MAGAZINE of New York, looked at the new political structures and told his American readers that Birmingham had become "the best-governed city in the world".[1]

The London art critic, Alfred St.Johnston, looked at the new architecture, the new art gallery, the new art school, and the thriving Royal Birmingham Society of Artists and told his readers in THE MAGAZINE OF ART that, "the Birmingham of today is perhaps the most artistic town in England."[2]

Ralph's tag has been immortalised and is frequently quoted. It is accepted that Joseph Chamberlain's Birmingham had become the model for

imaginative local government. Under his dynamic leadership, Birmingham was easily the most progressive example of municipalisation in Britain.

But what of St.Johnston's claim?

Was Birmingham the most artistic town in England?

Surely it would have been more accurate to describe it as a busy, industrial sprawl of hardware manufacture at the heart of an urban district so dirty and smoke-laden that it was known as the "Black Country".

Of course it would, but St.Johnston's claim was not an isolated one. An examination of now forgotten, contemporary accounts, by residents and visitors alike, reveals that his claim had widespread support. His was far from being the only voice to declare that Birmingham had become an "artistic" city of modern buildings, well-attended contemporary art exhibitions, and progressive art education.

The importance of art to Birmingham was even recognised by the choice of heraldic supporters for the new civic coat of arms. When the town was made a city in 1889, symbolic figures were placed on each side of the shield. A burly blacksmith, representing "Industry" was an obvious choice, but his female companion was not "Commerce", or some Victorian virtue like "Fortitude", but "Art". So, it looks as though the city fathers realised that Birmingham's success owed something to art.

If so, what? No other industrial town appears to have given art such a high profile.

Contemporary sources confirm that art was more important in Victorian Birmingham than is generally realised a century later. These sources also provide evidence for the case that nineteenth century art should be viewed with a less Paris-centred perspective. Of course Paris was the mecca for artists in the decades culminating in the Belle Epoque, but a considerable amount of artistic activity was going on in other cities throughout Europe and North America. Perhaps in no other period in history was art, in all its manifestations, quite so visible and quite so ubiquitous. Contemporary painting was appreciated at well-attended exhibitions, public art galleries were opened in every large town, the latest pictures reached a wide audience through cheap reproductions and an expanding popular press. The latest architecture was admired for public buildings, banks, churches, even for the facades of factories disguised as Venetian palaces, whilst every suburban villa and terraced house sported Ruskinian capitals and gothic arches. Each Victorian interior was loaded with art, expressed on every object in household use. Fashionable artists and architects were important members of society. Their activities were reported in the press. They were feted and

showered with honours from the Academies and Courts of Europe. They were not starving in garrets!

To continue to maintain, as most histories of art still do, that, throughout the nineteenth century, art was only happening in Paris, ignores a considerable body of painting which was created, exhibited, and enjoyed, in many other cities throughout Europe. Of course, no-one would deny the importance of Paris, especially in the development of Impressionism and Post-Impressionism. But it is worth re-assessing the contemporary evidence to ponder on the extraordinary popularity of English artists like Millais, Hunt, Rossetti, Alma-Tadema, Leighton, Watts and Burne-Jones, and the influence of English art critics like Ruskin, in Paris and other European capitals, as well as in London.

For example, at the 1878 Paris Exposition, four years after the first Impressionist exhibition, Albert Duranty, the French critic, having examined the entries from many countries, did not single out the work of contemporary French artists but concluded that, "above all towers English art, original, delicate, scrupulously true, expressive....full of historical sentiment which joins modern things to the lofty accents of the past....an art in which melancholy is joined to pleasure, and singularity to precise reality."[3] It was "the penetrating eye" of Millais, which received his greatest praise.

The young Vincent Van Gogh collected the English illustrated periodical THE GRAPHIC and admired "a couple of pages by Fildes – realistic yet done with sentiment."

Camille Pissarro, the Impressionist painter, writing to his son from Eragny, noted about Birmingham's reception of the Pre-Raphaelites, that "the provinces in England are more sympathetic to innovators – it is just the opposite in France, where the provinces are so bourgeois and pusillanimous."[4]

The styles which flourished in the visual arts in the second half of the nineteenth century were mostly variations of narrative realism. There were many modifications and "isms". Themes, subjects, symbols, could be plucked from a bewildering range of sources. The possibilities were constantly being extended by an increasing knowledge of other cultures, other times, and other continents, as Europe's Empires extended across the rest of the Globe. But it is generally true that paintings created between 1840 and 1900 are representational images based on careful observation of the natural world, but in addition, they usually have a meaning or tell a story.

Whilst variations of Impressionism eventually triumphed in France, one of the most pervasive "isms" of the day in England, had been formalised in the

eager debates of a small group of art students in 1849. From their rather scanty knowledge of Italian painting, they claimed to draw inspiration from the art before the time of Raphael. So, jokingly, they called themselves "Pre-Raphael-ites". Their ideas were not totally new but they caught a spirit of the age, and provided a focus for English painting for the rest of the century. The art movement they inspired became known as "Pre-Raphaelitism."

The Pre-Raphaelites sought to counteract the stale conventions of Classical painting by a fresh and painstaking analysis of the natural world and a jewel-like brilliance of colour. But what made their work so different from their French counterparts, was their desire to create, not merely beautiful paintings, but "thoroughly GOOD pictures". They demanded serious subjects, uplifting subjects, which would enable a Pre-Raphaelite painting to "take its proper place besides literature", as John Ruskin was pleased to approve.

The description the French art critic Albert Duranty gave to English painting as "original, delicate, scrupulously true, expressive....full of historical sentiment which joins modern things to the lofty accents of the past....an art in which melancholy is joined to pleasure, and singularity to precise reality," is a fair definition of Pre-Raphaelitism.

It found many forms, through the intense observation of John Millais to the colourful imagination of Gabriel Rossetti, from the sermonising subject-matter of Holman Hunt to the visionary symbolism of Edward Burne-Jones. Pre-Raphaelitism extended to architecture and interior design through the extraordinary design partnership of William Morris and Burne-Jones, and permeated every aspect of art and design through the subsequent Arts-and-Crafts Movement which spread rapidly across Europe and North America.

This view of the English contribution to the art of the nineteenth century needs to be taken before we can evaluate the importance of Birmingham as an artistic centre.

Fortunately, this is beginning to happen, and the part played by Birmingham and its artists is being rediscovered and recognised.

In 1989, John Christian organised a splendid exhibition at the Barbican Gallery – "The Last Romantics – Burne-Jones to Spencer" which acknowledged the key role of Burne-Jones in this formerly-neglected strand of British art. There was a complete gallery devoted to his followers from Birmingham – the "Birmingham Group".

The Birmingham Art Gallery has staged a series of exhibitions including – Joseph Southall 1980; Arthur and Georgie Gaskin 1981; Walter Langley 1986; Gerald Brockhurst 1987; Masterly Art 1987; The Birmingham School 1990;

which have enabled us to re-discover the work of these under-valued Birmingham artists.

In 1984, Alan Crawford, of the Victorian Society, brought together a fascinating set of essays about the Arts and Crafts Movement in Birmingham, entitled BY HAMMER AND HAND, which showed the wealth of artistic activity which was being practised in Birmingham at the end of the nineteenth century.

Stephen Wildman, of the Birmingham Art Gallery, has produced two scholarly and lavishly illustrated publications – THE BIRMINGHAM SCHOOL (1990), and VISIONS OF LOVE AND LIFE: PRE-RAPHAELITE ART FROM THE BIRMINGHAM COLLECTION (1995), which display the range and quality of artists from Birmingham and of art in Birmingham.

In 1994, Paul Atterbury and Clive Wainwright staged a sumptious exhibition at the Victoria and Albert Museum on the Gothic-revival work of Augustus Pugin, much of it created in Birmingham by John Hardman.

This book sets out to examine the artistic activity in a particular English city between 1850 and 1900, and to show why that city proved to be so receptive to Pre-Raphaelitism.

It discovers the influence of Pre-Raphaelitism on the thinking and practice of Birmingham artists, whether they were painters, architects, designers, or craftsmen and women, for art is not only easel painting.

It considers the involvement of individuals, including Augustus Pugin, William Aitken, John Hardman, John Hardman Powell, Edward Burne-Jones, William Morris, John Ruskin, William Kenrick, Joseph Chamberlain, John Henry Chamberlain, Whitworth Wallis and Edward Taylor.

It reveals the key role of the art institutions, especially the Royal Birmingham Society of Artists, the Municipal Art Gallery, and the Municipal School of Art.

It discovers how Pre-Raphaelitism and the Arts-and-Crafts Movement inspired a whole generation of Birmingham artists, including Arthur Gaskin, Charles Gere, Edmund New, Kate Bunce, Mary Newill, and Joseph Southall.

It claims that through all these creative activities, from Pugin to Southall, a scarlet strand of Pre-Raphaelitism was intertwined in a manner that was not to be found in any other English city. And it argues that the civic culture peculiar to Birmingham, provided a unique climate in which the resulting art, whether as architecture, or painting, or across the whole field of applied design, was more visible, and more important, to the citizens of Birmingham than could be claimed to be the case today.

It hopes to show why alongside its well-merited titles of "Workshop of the

World" and "Best-governed city in the World", Birmingham could also claim in the 1880's to have been "the most artistic town in England."

References

1. *Harper's Monthly Magazine* June 1890. New York 1890 "The Best Governed City in the World" by Julian Ralph.
2. *The Magazine of Art* London 1887. "The Progress of Art in Birmingham" by Alfred St.Johnston.
3. MILLAIS, J.G. *The Life and Letters of Sir John E.Millais* Vol.II 1899. p.102.
4. REWALD, J. Ed. *Camille Pissarro: Letters to his son Lucien* 1943. Letter from Eragny, 5th November 1891.

CHAPTER 1

ART IN BIRMINGHAM: 1800-1850

In the summer of 1850, three young artists submitted their latest paintings for public exhibition in London. William Holman Hunt, aged 23, and John Everett Millais, aged 21, exhibited for the second year running in the Summer Exhibition of the Royal Academy. Both showed ambitious figure compositions carried out in bright colours with meticulous attention to detail. Hunt had selected a subject from ancient British history – 'A Converted British Family sheltering a Christian Priest from the persecution of the Druids', whilst Millais took an imagined incident from the life of the boy Jesus – 'Christ in the House of His Parents'. The third artist, Gabriel Dante Rossetti, aged 22, exhibited an 'Annunciation' at the Portland Gallery. Each added the initials "P.R.B." to his signature. When it was discovered that this stood for "Pre-Raphaelite Brotherhood" the pictures were greeted with considerable hostility by the press. Millais's picture in particular received the full brunt of an attack by no less a critic than Charles Dickens.

The young artists were disheartened, but despite the criticism, Millais and Hunt persevered and the Academy accepted their work the following summer. Millais entered a subject chosen from the Old Testament, 'The Return of the Dove to the Ark' and Hunt chose a scene from Shakespeare – 'Two Gentlemen of Verona; Valentine rescuing Sylvia from Proteus'.

The press was still hostile, but the powerful art critic, John Ruskin, claimed in his latest volume of MODERN PAINTERS, that these two paintings were "in finish of drawing and splendour of colour, the best works in the Royal Academy," and boldly predicted of these young men that "they may become the foundation of a more earnest and able school of art than we have seen for centuries."

News of this controversy reached Birmingham.

William Michael Rossetti, who acted as secretary for the Brotherhood, recorded in THE PRE-RAPHAELITE JOURNAL in May 1851, that he had received "a particular invitation from the Birmingham Exhibition for Millais to send 'Dove in the Ark' thither."[1] There was no public art gallery in Birmingham at that date, so who had sent the invitation, and what was the "Birmingham Exhibition"?

Despite the lack of a public art gallery in the 1850's, there was a thriving Society of Artists, there was considerable interest in contemporary art, and, surprisingly, there was more opportunity to see the latest examples of modern painting than were to exist in the 1950's.

How had this come about?

The first exhibition of contemporary painting had been held in Birmingham as far back as 1814.

On April 11th of that year, THE BIRMINGHAM ADVERTISER had announced the formation of a Birmingham Academy of Arts. It was to be modelled on the Royal Academy of Arts in London and would provide encouragement for any local artist "to have his powers excited and his attainment rewarded".

An exhibition of paintings was held in September in a rented room over the Fire Engine House in Union Passage, and an appeal was made for funds with which "to erect a handsome building, where the Academy will be permanently established, and where the artist, whose talents might otherwise continue buried in obscurity, will, by means of the annual exhibition, have an opportunity of giving effectual publicity to his productions." The appeal failed, no funds were forthcoming, no other exhibitions were arranged.

But who were these Birmingham artists?

At the beginning of the nineteenth century it was virtually impossible for a young woman living anywhere, and extremely difficult for a young man living outside London, to consider becoming a professional artist or designer. The few established artists who might take pupils were nearly all in London, as was the only art school. Without substantial private means, the only way to obtain any sort of art education was to attract the support of a wealthy or aristocratic patron who might finance a hopeful prodigy to attend the Royal Academy Schools, or even pay for his discovery to travel on the Continent to study from the Old Masters. Even after many years of study, in England or abroad, the aspiring artist had only one opportunity to present his work to a wider public. This was at the over-crowded annual exhibition of the Royal Academy, established as recently as 1768. If his work was hung sympathetically there he might hope to attract purchasers and attempt to establish a reputation. This very restricted path applied specifically to the practice of easel painting.

However, for an ambitious young man in Birmingham, the new demands of the proliferating craft-intensive "art-industries" of the town, opened another route which was less hazardous and offered a wide variety of

steadier prospects and better financial inducements than the uncertain world of "fine art".

Within the Midland concentration of hardware, jewellery, glassware, papiermache, and a bewildering variety of new manufacturing processes, there was an increasing demand for skilled, visually-literate craftsmen, whether they were japanners, engravers, die-sinkers, medallists, pattern-makers, modellers, carvers, jewellers, silver-smiths, gold-smiths, gun-smiths, lock-smiths, sword-makers, 'toy'-makers, electro-platers, brass-founders, button-makers, buckle-makers, or many sorts of engineer. The demand from these new industries heavily favoured men, unlike the textile industries of Lancashire and Yorkshire, and the ceramic industries of Staffordshire which exploited the nimble fingers of young women. It was essential for most of these craftsmen to be able to understand drawings, and for many of them it was necessary to be able to both visualise and draw themselves. As one Birmingham designer put it, "every individual who comes into contact with workmen knows, how much more useful is he who can draw than he who cannot."[2]

A glance at the ornate decoration and elaborate detailing of most nineteenth century artefacts will confirm the common sense of this statement.

In the rapidly expanding design-field of the early years of the century, some of those self-taught art-workmen set themselves up as free-lance designers and offered their design services to a variety of trades. They then formed a better-paid elite of what would now be called industrial designers, and found themselves rubbing shoulders on equal terms with manufacturers and small industrialists. As their practice increased they could take on assistants and apprentices so that their studio-workshops often began to double as design schools.

So two facts emerged very early on. In the Birmingham metal trades created by the Industrial Revolution, successful designers frequently achieved equal status with their employers, and there was a high demand for education in design-skills, especially draughtsmanship.

Two Birmingham designers set up establishments to provide general drawing instruction which was separate from their own design workshops. They were Joseph Barber and Samuel Lines.

Joseph Barber moved his School to the corner of Newhall and Great Charles Streets in 1803. His students included David Cox, who studied with him from 1801 to 1803 whilst working as a scene painter at the Theatre Royal, before leaving for London to become a teacher of drawing and then taking to landscape painting.

Samuel Lines in his delightful biography,[3] gives an account of his early years on a farm near Coventry, of how he was inspired to become a painter after seeing a portrait of George III, newly painted by Thomas Lawrence and presented to the citizens of Coventry (now in the Herbert Art Gallery), of how he walked to Birmingham and secured his apprenticeship, and eventually prospered as a painter, designer and teacher.

Barber worked as a designer for the flourishing Birmingham-based papier-mache industry before opening his School in Edmund Street in 1801, and the young Lines, whilst still serving his five-year apprenticeship to a clock-dial enameller, managed to corner a lucrative market in gilded inscriptions on presentation swords for officers serving in the Napoleonic Wars.

In 1807, Samuel Lines announced his plan to open a Drawing School for "correctly delineating the Human Form....at the same time keeping in view Landscape and Ornament." It took place in a room rented for £5 a year, and Lines recorded that his eager students "attended lessons at five o'clock in the morning, which for a number of years was my custom during the summer months." In these early drawing schools the younger students drew in outline from flat "copies", mostly consisting of large engravings of fragments of classical sculpture, whilst the older students progressed to "drawing from the statue and the round generally." In other words, they drew in outline, in the manner of Flaxman, from plaster casts of classical models and from simple, white-painted objects. After an hour's drawing his students left for a long day's work in their respective trades, leaving Lines free either to work on his own design commissions or to instruct individual young ladies in their homes to acquire the accomplishment of water-colour painting. Lines ranged across the parallel fields of fine art and applied design with ease.

For forty years Barber's and Lines's Schools continued to offer a foundation in basic drawing skills for a large number of young men who went on to become successful designers and, sometimes, successful artists. In 1847, at a testimonial dinner to mark Lines's seventieth birthday, the ART UNION stated, "If there was one individual to whom the town and its manufacturers in particular were more indebted than to others, it was to Mr Lines. Scarcely one of its manufactures could be said to have received no benefit from that gentleman's labours; and it must have been a great gratification to Mr Lines to have seen those who were his pupils five-and-twenty or thirty years ago steadfastly working their way to the highest positions in their native town."

In 1854, Lines was able to boast that at the Great Exhibition forty-two of

the leading designers showing work from Birmingham manufacturers had passed through his school.

Barber and Lines produced another group of draughtsmen who migrated to London where they took up engraving and were soon identified as the first collective "Birmingham School". It was not long before these Birmingham men dominated the field of high-quality line engraving, a position they were to hold for several decades before their time-consuming and labour-intensive skills were superseded by cheaper, and far quicker, photographic techniques of reproduction.

These Birmingham engravers brought about a revolution in the art of book illustration. Artists such as James Tibbetts Willmore ARA, worked with great skill to translate the rich colour of painters like Turner into black-and-white engravings which helped to stimulate the proliferation of illustrated books and magazines which transformed the printed page during the 1850's and 1860's and brought art, and particularly contemporary art, to the notice of a wider public.

In this period of Neo-Classicism, dominated by Adam, Flaxman and Wedgwood, the nude or draped nude figure was a frequently-occuring component of many manufactured items, either in relief or in the round. So, in 1809 Lines set up a separate Life Class. In a rented room in Peck Lane, a small group of young men met regularly to draw from the life model under his instruction, with the help of a local veterinary surgeon, Richard Lawrence. But more significant than his anatomical advice, must have been Lawrence's personal contact with Greek sculpture, because he was currently making drawings from the newly-arrived remnants of carvings rescued from the Parthenon which were then in temporary store in Park Lane, London. The "Elgin Marbles" were already attracting the attentions of Flaxman and Haydon, but were not generally known to a wider public, so Lawrence's connection must have been very stimulating back in the little provincial life class in Peck Lane.

Yet another need was recognised when Lines advised a group of his senior students that, "as most of them had arrived at manhood", they might "form themselves into a society and occupy a room for the life study independent of a teacher." So, nine young men rented a room off Edmund Street and declared themselves to be the Society of Birmingham Artists.

After a decade of activity, with the establishment of elementary drawing instruction, life classes, and an artists group, there was now a growing realisation that besides designing and teaching, there might be a wider potential market if only an appropriate institution could be created In order

to achieve wider public recognition as artists and designers, they saw the need to establish themselves on a more permanent and professional footing.

Accordingly, the Birmingham Academy of Arts was formed in the Spring of 1814 by a group of professional artist-designers supported by some sympathetic amateur painters. They were Henry Allport, Charles Barber, Joseph Vincent Barber, Henry Hutchinson, Samuel Lines, William Radclyffe, William Roberts and Philip Witton, with John Gunby, James Russell and Francis Tombs.

Although this attempt failed, its promoters realised the wider cultural significance of an Academy of Arts. It could become much more than a mere shop for painters to sell their wares; it could become a centre of excellence, a focus for both art and design, leading to greater public appreciation of contemporary painting and to improvements in the design of local manufactured goods; it could become a cultural resource and aesthetic powerhouse for the whole community. It seemed clear to the promoters of the new Academy from the beginning that Birmingham needed some such cultural institution.

Many towns at this time were setting up Institutions to air philosophical, agricultural, and scientific matters, but Birmingham had identified her immediate need to be an organisation to encourage arts and manufactures. A local benefactor offered to present a collection of plaster casts taken from antique sculptures to form the basis of a design museum. Sir Robert Lawley Bt, of Canwell Hall, was willing to give this collection of casts to the town if a suitable institution could be formed to accept them and a suitable building be found to accommodate them.

On the 1st January 1821, an announcement appeared in ARIS'S GAZETTE that "an Institution....for encouraging the cultivation of the Fine Arts" might be established. It regretted that there were no permanent collections of "approved specimens of sculpture, for the imitation of our artists" and hinted that there was a possibility that if an institution could be created it would be presented with a "numerous and very valuable collection, comprising models of nearly all the most approved statues of antiquity, and of other specimens of sculpture more applicable to the purpose of many of our manufactures."

The article continued that with sufficient funds it was hoped to set up "a Museum....which will afford the means of forming and correcting the taste of the rising generation, and contribute essentially to the improvement of all those branches of manufacture which are most susceptible to decoration."

At a public meeting chaired by Samuel Galton FRS, it was resolved to

establish a society for the encouragement of Arts and Manufactures, with a museum, a drawing school, and exhibition facilities.

The Constitution of the new society shows that it approximated more nearly to the national Society for the Encouragement of Arts, Manufactures and Commerce, (later known as the Royal Society of Arts), than to the Royal Academy of Arts, and reflects the different perspective of its founders. They saw its priority as providing a resource of art objects to be used for the education of the designer and the consumer, which would somehow lead to an improvement in the design, (and the sale?), of Birmingham's manufactured goods. Only if it was deemed "expedient" would any exhibitions of painting be staged, and then not necessarily of contemporary painting. This was very different from the abortive Academy of 1814, which had remained completely in the hands of the artists themselves. The new Society of Arts never really understood the needs of living artists, and so there was an uneasy relationship from the start.

'View from the Dome of St. Philip's' 1821, (detail) by Samuel Lines 1778-1863. The back of the circular Panorama building can be seen between the Theatre Royal 1777, and Christ Church 1814. All now demolished.

Nevertheless, the Birmingham Society of Arts declared its intention "to promote extensively and efficiently the study of the Fine Arts as connected

with Manufactures, by providing ready means of acquiring correct taste, and affording to the artists and manufacturers of Birmingham an opportunity of making their talents known to the public." The following April, the Society found a temporary home for their promised collection of casts in a vacant building at the top of New Street. This was a circular shed built of wood known as the "Panorama" which had been erected in 1802 by Robert Barker, the London impressario, who had used it to display his renowned panoramic canvases illustrating recent naval battles or landscape scenes from the Colonies. When this novelty had palled, the structure had been let as an auction room, but it was now vacant.

Birmingham was hardly a place of beauty and culture to be compared with Bath or Buxton. Thomas Carlyle described Birmingham in a letter to his brother. "As a town it is pitiful enough....the streets are ill-built, ill-paved, always flimsy in their aspect – often poor, sometimes miserable....Torrents of thick smoke are issuing from a thousand funnels....I have seen their rolling mills....their iron-works....their coal-mines, fit image of Avernus....the whole is not without its attractions, as well as repulsions...."[4]

His decription brings alive a scene that seems so remote from the elegant drawing-rooms of Regency England, and yet it was here that so many of the prized artefacts that graced these rooms were being forged and fashioned. Besides the poor streets, there were no public buildings, no public services or amenities, and no general educational provision. There was an extensive working canal network but the railways had not yet arrived, and the town was an uncontrolled sprawl of noisy, smoking workshops and rookeries of insanitary tenements.

A Society of Arts must have seemed somewhat pretentious.

However, nothing much seems to have happened. Access could be obtained to the dusty casts by anyone who wished to draw them, and in 1826 the Society agreed to a request from Lines and Barber to permit the use of the large room for drawing classes from the life model. The Committee also half-heartedly agreed to hold an exhibition of paintings, but procrastinated over the arrangements, with the result that the artists angrily petitioned the Committee to announce the sending-in dates. Five more months passed and the artists received no reply, so they informed the Committee of their intention to go ahead with their own exhibition. Stung into action, the Committee responded by calling a meeting which agreed to the erection of a permanent exhibition gallery on land which the Committee had already leased adjacent to the wooden Panorama. There was more procrastination, accusations passed to and fro, but eventually a successful exhibition of

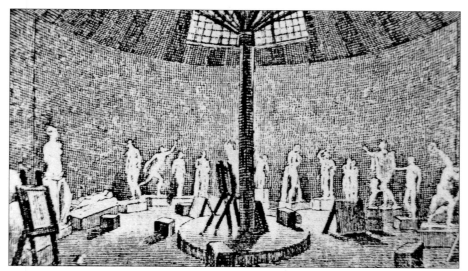

The Academy of Arts from THE HISTORY OF BIRMINGHAM published by Beilby, Knott and Beilby, April 1830. The interior of the Panorama, showing the casts of sculpture.

paintings was held in the Panorama in the Autumn of 1827. It even made an unexpected profit of £300 for the Society.

The Committee then announced their intention to mount another exhibition in 1828, but unwittingly proposed that it should consist of the works of "Old Masters". The local artists response was immediate, and to the point. "It is not by such exhibitions that the artist is to live....they in no way conduce to the sale of his works or to the enlargement of his connections."[5] The previous year's exhibition had been the only opportunity the Birmingham artists had had to show their work since 1814, and following the success of that exhibition they now felt so aggrieved that they decided to carry out their threat to form a rival society and began to erect an exhibition gallery in Temple Row, next to St.Philip's churchyard. The Committee of the Society of Arts responded by haughtily announcing that they would forbid any artist from exhibiting with them if he showed work with any rival society declaring "there is no room for two Societies – one must give way!"

This conflict reflects a split in the perception of the role of exhibitions, even of the role of painting, that emerged in the early years of the nineteenth century. It was a conflict between the traditional patrons of art and the rising new patrons, between the established upper class and the new middle class.

For the relatively few, wealthy landed aristocrats, who had received an

education in the Classics, undertaken the Grand Tour around Europe, and returned to inherit enormous country estates surrounding a mansion that had been built, or re-built, by their grandfathers in imitation of Roman temples or Italian palaces, painting usually meant sizeable pictures by the "Old Masters". They might be Italian, French or Dutch, but rarely English, and they were preferably safely dead. Such pictures illustrated incidents from Greek mythology, which was comprehensible only to one's social equals who possessed similar homes and shared the same background, education and wealth. These paintings were complemented by many portraits, (some by English artists), purchased not as specimens of art, but to provide permanent visual affirmation of pedigree.

For the rapidly-increasing, new middle class patron, who had spent his youth working long hours at a bench or a counting-desk, instead of learning Latin and Greek, and had struggled to prosper in his own business, this aristocratic art was dull and its meaning obscure. He needed paintings to hang in his newly-built suburban villa which would complement the new furniture and set off the new wall-paper. It followed that such paintings should also be new, and, like the furnishings, they should be conspicuous for their value-for-money, by their obvious time-consuming detail and effort. They should be purchased direct from the artist, newly-painted, brightly-coloured, up-to-date, with no possibility of being faked or subject to a dubious attribution by greedy middle-men or expensive "art-experts". Nudity was not considered suitable for one's daughters. The paintings might bring to life a moralising anecdote from the Old Testament, or illustrate a passage from Walter Scott, which would be easily comprehensible to one's neighbours, with similar reading tastes and who were also self-made in commerce, business or a profession, and who were busy furnishing their own new villas. Others might depict an awe-inspiring landscape, or a reassuring rustic scene, and there might be a smattering of portraits to lay claim to a pedigree.

The original patrons of the Birmingham Society were land-owners and naturally subscribed to the aristocratic view of painting, but already there were some from the town-based commercial bourgeoisie who took an opposing point of view.

This fundamental difference in the perception of the role of art is one clue to understanding why there was an upsurge in the demand for contemporary painting. For it was to remain true for the rest of the nineteenth century, that whilst the upper classes continued to trade in Old Masters, the rapid expansion of an increasingly wealthy middle class led to

an unparalleled demand for modern paintings. This demand was further fuelled by the flourishing trade in reproduction rights which produced large engravings of the latest fashionable pictures which were bought by both the middle and working classes in great numbers. This brought royalties to the astute artist, and revenue to the publisher, and conferred as much status on the front parlours of the terraced house, as the originals gave to the drawing rooms of suburban villas. It now becomes clear why the Birmingham artists wanted to stage exhibitions of their work. It was in order to reach this new middle class group of potential patrons, who were growing in number in Birmingham.

It is interesting to consider the different impact of this situation on Manchester. Its new wealth had been founded on vast textile mills which had created a new aristocracy of extremely wealthy mill-owners whose palatial new homes were mirrored on those of the established landed gentry. Therefore art patronage in Manchester more closely followed the existing aristocratic pattern of purchase than it was to do in Birmingham. And, of course, the sudden demand to provide an instant cultural setting for these wealthy cotton barons, inevitably led to a thriving trade in art-works with dubious attribution and many downright fakes. In these circumstances the newly-rich mill owner was not likely to be encouraged by unscrupulous dealers to collect new pictures by a verifiable living artist. It had to be the obscure tonalities of the Old Masters, grimy with age, no matter how dubious their authenticity. Instant antiquity was required. This meant that there was less demand for local exhibitions and less interest in the radical subject-matter and brighter palette of much of contemporary painting. Moreover, having just risen from the world of trade or commerce, these nouveau-riches did not wish to be seen hob-nobbing with painters whom they considered to be little better than tradesmen.

The situation in Birmingham was very different, both in the 1820's and later during the civic achievements of the 1880's. There were very few extremely wealthy industrialists in Birmingham. The town's prosperity throughout the century came from the profits of a multiplicity of smaller workshops and factories and so the patronage of art catered for the requirements of the prosperous bourgeois villa, rather than the grand manner of either the older aristocracy or the extremely rich, Manchester-style, cotton baron.

The Birmingham artists clearly had everything to gain from encouraging a demand in Birmingham for contemporary pictures. This is why they were so opposed to an exhibition of Old Masters. As they had stated, quite bluntly, this would not bring them work or income.

Despite the threats from the Committee of the Society of Arts, the Birmingham artists refused to capitulate, with the result that in 1828 the smoke-laden town whose squalor was so vividly described by Carlyle actually enjoyed two major art exhibitions.

In the Panorama in New Street, – "Pictures chiefly by the Ancient Masters of the Italian, Spanish and Flemish Schools", and in brand-new galleries in Temple Row, the break-away artists showed their own paintings alongside contributions gleaned from London artists including Sir Thomas Lawrence PRA, Constable, and Wilkie.

The following year there were again two rival exhibitions. But the members of the Society of Arts had not been idle. They had pulled down the Panorama and erected new galleries to the design of Thomas Rickman and Henry Hutchinson.

There was now a finely-proportioned stone portico extending across the pavement in New Street, supported on Corinthian columns. Inside, was a

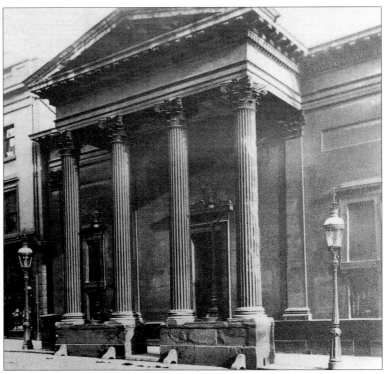

The Birmingham Society of Artists' Gallery, New Street.
Designed by Thomas Rickman 1776-1841, in 1829. Demolished 1913.

circular exhibition room, fifty-two feet in diameter, with a coffered dome lit from above. From this gallery opened a library, a room for the display of sculpture, a smaller octagonal gallery, a room for exhibiting prints, and another for water-colours.

Carlyle's Birmingham was changing. THE EXAMINER informed its readers that "in Birmingham, heretofore caricatured as the abiding habitation of all that was ungraceful, incongruous and clumsy," they would now be "greeted by a fabric of high architectural pretension dedicated as a school of instruction and a place for display for the Advancement of the Fine Arts."

The inaugural exhibition in 1829 was a resounding success as a representative exhibition of contemporary British art. THE EXAMINER was in ecstacy, "a magnificent Pantheon....which of us has ever before in any assemblage of modern paintings beheld a galaxy of greater excellence? We are transported into Fairyland!" THE BIRMINGHAM JOURNAL was impressed. Noting the paintings of Thomas Creswick, S.H.Baker and Samuel Lines, it argued that,"the Birmingham School will now rival the highest: and its ameliorating effect must extend over the characteristic productions of this large manufacturing community.... checking any disposition to ungraceful and incongruous combinations in the work of our designers....cherishing and encouraging purer taste....and contributing to the commercial prosperity of the town."

A series of weekly Soirees or Conversaziones was staged in the evenings in the Galleries during the exhibition and were a great success. Over two thousand guests accepted invitations to attend. The Great Room was "illuminated almost to day pitch....filled with an elegantly dressed assemblage....ladies in full evening costume....knots of artists interchanging friendly remarks on each others works....the pictures tinged by artificial light seemed to borrow new beauties....the comestibles, all that is tempting and sapid to the genus biscuit....unfailing supply of tea and coffee, strong and hot....all managed with a degree of taste and elegance."[6]

This sounds much more like a scene from the Assembly Rooms at Bath.

The breakaway artists staged their rival exhibition in Temple Row with equally strong support and sales. Many Academicians loyally sent work to this exhibition as well, and it was the outstanding financial success of both exhibitions which led the Committee of the Society of Arts to propose a reconciliation. Meetings were held and a new structure agreed. There were to be two committees. The Unprofessional Committee, consisting of fifteen gentlemen to be elected from the donors and subscribers, and the

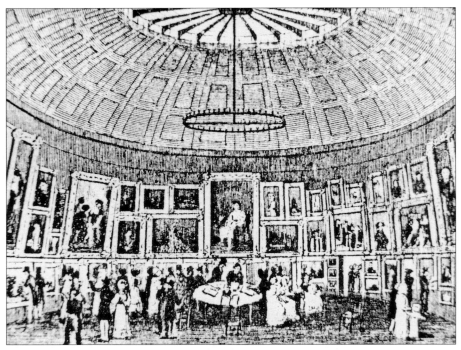

The Society of Arts Exhibition Rooms from THE HISTORY OF BIRMINGHAM published by Beilby, Knott and Beilby, April 1830. The interior during the 1829 Autumn Exhibition.

Professional Committee, consisting of fifteen artists who would now be known as Members of the Society of Arts.

The Temple Row galleries were rented to a literary club, and the artists returned to New Street.

The exhibitions throughout the 1830's were successful in terms of quality of exhibits, increasing sales and rising attendance. The organisation and staging of these exhibitions must have involved an enormous amount of time and effort in canvassing eminent artists to show paintings, arranging a London collection point, and organising transport to Birmingham. Before 1837 this was by horse-drawn wagon over poor roads. After 1837, when the railway reached Birmingham, a special truck was added to the London train and must have made the operation simpler, quicker and less hazardous. For the exhibitions of "deceased masters", more correspondence was necessary to track down and request the loan of suitable pictures, followed by the compilation of the scholarly and beautifully-printed catalogues. Again the

organisation of transport from country seats as far away as Chatsworth must have been a considerable undertaking. It must be some measure of the perceived importance of the Birmingham Society that both established painters and wealthy collectors were willing to lend their paintings to these annual exhibitions.

The 1830 Exhibition was visited by the Duchess of Kent and her eleven-year-old daughter, Princess Victoria (later Queen), who were staying at Hewell Grange.

In 1834, Constable sent 'Salisbury Cathedral from the Meadows', and in 1839 'The Opening of Waterloo Bridge' was hung near Cox's 'Crossing the Sands'. In 1840, a typical 'Cattlepiece' by Sidney Cooper was awarded a premium of £50 as the best work in that exhibition. The increase in sales was seen as a "proof of the advancement of refined taste in this community."

THE BIRMINGHAM JOURNAL, commenting on the exhibitions held in 1829 and 1830, remarked that, "the Society of Arts is important to Birmingham, not because brass-founders want to be taught the canons of abstract grace in the form of candelabra and cornice, but because it includes a great assemblage of human beings who claim to have before them the means of universal improvement and the means of that amelioration which the familiarity with fine works of art tends to bestow."[7]

This somewhat supercilious reference to Birmingham brass-founders needs to be placed in context. It must be remembered that "within a thirty-mile radius of Birmingham, nearly the whole of the hardware wants of the world (were) practically supplied....the metal works in infinite variety which Birmingham produces from the costliest plate and jewellery down to the commonest gilt toys, the engines and machinery of every description exported to all parts of the world."[8] This hardware industry was carried on in warrens of small workshops with something between six and twenty employees in each.

The French traveller, Alexis de Tocqueville, visiting the area in 1835 noted that there was "hardly any likeness" between Birmingham society and that of London. "These folk work as if they must get rich in the evening and die the next day. They are generally very intelligent people, but intelligent IN THE AMERICAN WAY."[9]

This restless drive, coupled with the largely immigrant and mobile population, gave Birmingham a rootlessness untypical of older British towns, more akin to the emerging new cities of the American mid-West, as De Tocqueville shrewdly noted. With no turbulent medieval past to provide an ancient legacy of hard-won charters and restrictive regulations, the town

was still organised politically under out-moded parochial institutions as though it was the merest village. But this very lack of controls had become a positive advantage by attracting entrepreneurs and dissidents from all over the British Isles and the Continent, many of them victims of political or religious persecution. They were attracted to Birmingham as "the industrious, the ingenious, and the persevering found this their natural home where each could develop his faculties unfettered."[10]

The multiplicity of trades meant that there were no large factories employing thousands of semi-skilled operatives. One consequence of this, and the nature of the hardware industry itself, meant that an unusually high proportion of the Birmingham work-force was highly skilled. The introduction of machinery, much of it designed and made in the town, did not have an adverse effect on employment in Birmingham. Machines usually served to cut down on the physical effort required for metal-working, rather than to supplant the metal-worker. The introduction of mechanisation therefore tended to increase the Birmingham craftsman's productivity, rather than replace him, as it was to do in the Lancashire cotton industry, with such disastrous results on wages and employment. Birmingham's workforce was generally better paid and worked shorter hours than those in other industries in other towns, and because of the smaller units of production, relations between employer and employee were, of necessity, more intimate than in a large impersonal factory.

So from the beginning of the century, the rising middle class brass-founder shared the conditions of his skilled craftsmen, and both were more conscious of their mutual dependence to survive the vicissitudes of the market. It is in this fluid context that we must place these struggles of the enterprising designer and aspiring artist with the thrusting industrialist and prospective patron as each sought to establish their professional identities and affirm their social status in the rapidly changing town as it entered the Victorian era.

By 1840, some of the objectives of the earlier Birmingham Academy of Artists had been achieved. Local artists had gained recognition and could participate in regular exhibitions staged in the splendid suite of purpose-built galleries in New Street. These exhibitions had begun to create a new cultural climate in which the middle classes could congregate and see some of the best modern British art, and the artists were winning the support of this local elite, who were increasingly interested in their work, and were willing to purchase it. The Society of Arts appeared to be functioning with some success in supporting art and artists, but one of the basic objectives of all the artistic

activity over the past forty years in Birmingham had still not been met. It was still apparent that the comparative quality of the design of locally-manufactured goods left a great deal to be desired. The hope that the presence of a gallery full of plaster casts of Classical sculpture, however evocative, and annual exhibitions of contemporary painting, however outstanding, would somehow penetrate to the designer, the manufacturer and the consumer of manufactured artefacts by some form of cultural osmosis and automatically ameliorate their perceptions, had not been realised.

Two external factors compounded this dilemma. First, by the 1840's, the accepted certainties about design and style were shifting throughout Europe. The familiar repertoire of Neo-Classicism which had flourished in the Napoleonic years and lingered through the reign of William IV was no longer fashionable. Taste was changing. As the century progressed into the Victorian era new influences began to turn the design process into a nightmare of options. A vast range of styles was appearing, which rejected the clear-cut lines and simplicity of Neo-Classicism.

Second, although the mechanisation of many industrial processes was speeding up productivity, it was evident that the integrity of design was not keeping pace with the new technology. Stamping was replacing hand-chasing, moulding was replacing hand-cutting, transfer-printing was replacing hand-painting, and the electrotype process at Elkington's could, quite un-selectively, reproduce any metal object as often as required. The integrity of hand-tooling and the truth to materials which had been painstakingly evolved by the craft traditions of centuries, handed on from one generation to the next, were being lost to the obvious detriment of manufactured design.

There was a perceived need for reappraisal, and perhaps for the first time in modern history, a nagging doubt as to whether the latest was invariably the best. There was a general unease about current design and therefore an urgent need to discover where British design was going, and if that could be discerned, to address the accompanying question – how to educate and train the next generation of designers to be able to orchestrate this growing cacophony of styles into viable, and competitively marketable, design for industry.

This problem was not peculiar to Birmingham. Of course it was extremely pertinent to the district as the centre of the hardware industry, but even Parliament, who did not normally concern itself much with such prosaic matters, was growing alarmed at the effect on trade of the perceived inferiority of British design when compared with imported products,

particularly French ones. In 1835, the House of Commons set up a Select Committee under the Chairmanship of William Ewart MP, and asked it to enquire into the "best means of extending a knowledge of the arts and principles of design among the people (especially the manufacturing population) of the country."

Their Report came to two depressing conclusions; one, that there was an alarming discrepancy between the generous provision for design education in France and the almost total lack of it in England; and two, "from the highest branches of poetical design down to the lowest connexion between design and manufactures, the Arts have received little encouragement in this country." The Report also noted that many witnesses stressed "the want of instruction in design amongst our industrious population."[11]

Following the Ewart Enquiry, the Birmingham Society of Arts petitioned the Government for financial support for a School of Design, but without success. In 1841, a second attempt was made and this time a prompt and favourable response was obtained. The Unprofessional Committee was prepared to accept the conditions attached to a Government subsidy. It hastily proposed the creation of a re-organised Society headed by a single committee, which would manage a new School of Design with a full-time Government-appointed teacher, who would introduce and teach the system of instruction laid down by William Dyce, Head of the new Government School of Design at Somerset House.

However, the artists on the Professional Committee, recalling earlier disputes, "firmly, but respectfully, protested." They felt that they had not been properly consulted and saw the proposals as a threat to their still-precarious professional status. It was a point of principle, and marked a critical moment for both the artist-designers of the town and the future provision for art and design education. The point at issue was, again, the perceived status of the artist-designer in a modern industrial society.

In 1814, a few Birmingham "artists" had managed to rise through humble apprenticeships to become skilled and visually-literate craftsmen, and progress to free-lance "designing". Then, instead of seeking to exhibit their designs or examples of the artefacts themselves, they had followed the received hierarchical approach to art and design and exhibited easel-pictures and laid claim to being "artists". They had formed their Academy of Artists. Within its successor, the Society of Arts, they had been accorded a "Professional Committee", but they had always felt that they had been forced to play a subservient role in the affairs of this body. That feeling was strongly re-inforced by this latest proposal. The Birmingham artists realised,

that by insisting on their independence and their professional integrity, they had, over the past few decades, achieved some standing in their community and were perceived as an important element of the town's establishment.

As well as laying claim to be the equal of engineers and architects, the artist-designers also wished to confirm their status in the new middle class as being the equal of the successful businessman or the prospering industrialist.

The upshot of this important struggle between the two committees of the Birmingham Society of Arts, between the artists and the subscribers, was a final separation. After twenty years of uneasy relationship, the two interests parted and set up separate institutions.

The first was known as the Birmingham Society of Arts and School of Design. Now in receipt of Government subsidy, its Committee ceased to stage exhibitions and devoted its entire energies to organising the School. The second was named the Birmingham Society of Artists, and its members were now in a position to concentrate on their primary task of establishing an independent fraternity of professional artists and providing them with the facilities of annual exhibitions.

The Society of Arts continued to occupy the building in New Street, whilst the Society of Artists returned to their former galleries in Temple Row. These had been designed by the architect William Hollins, who had been a member of the original breakaway group in 1828. On the ground floor was a large Sculpture Room, and on the first floor, approached by a grand staircase, were two spacious top-lit galleries – the Great Room, nearly a double cube, and the Watercolour Room.

The artists set about electing officers and invited the President of the Royal Academy to serve as their honorary President. Sir Martin Archer Shee accepted and as THE ART UNION reported, "with the high feeling that has distinguished his public career, stamped their importance with the fiat of his name, and ascended their presidential chair."[12]

The artists who had been instrumental in bringing about the new Society were led by the painters Samuel Lines and Frederick Henshaw, and the sculptor Peter Hollins. It should be noted that all three were also successful designers for a variety of trades in the town.

Lines was well-known as a designer, a painter, and an educator, and was on intimate terms with the town's middle class. Henshaw had an established reputation as a landscape painter, and Hollins was to play a vital role in the politics of the art scene in Birmingham for over forty years, for thirty-seven of which he was the Vice-President of the Society of Artists. In effect this

meant Hollins was the driving force behind the Society. As the youngest member of a distinguished artistic family, he became a much respected figure in the town and was recognised nationally as a talented sculptor who had studied with Chantrey. He was a leading designer, sculptor and architect, rather than a painter, and as a second-generation member of an established Birmingham family he was accepted as a member of the town's middle class.

The members of the new Society included David Cox, who, after following a career which had established him as one of the country's leading landscape painters, had recently returned to live near Birmingham in order to be among his fellow-artists. His work added lustre to their exhibitions.

In July 1842, artists throughout the country were circularised by the new Society appealing for support. The response was immediate and the Birmingham artists "were encouraged by the generous and almost unanimous support of their metropolitan brethren".

Most of the leading artists of the day responded and were represented in the resulting Autumn Exhibition which "formed a collection unrivalled in the history of provincial exhibitions", and was hailed as "the best ever seen outside London". The press particularly noted 'Dignity and Impudence' by Edwin Landseer, lent by Jacob Bell.

Despite the former friction between the two committees of the old Society of Arts, many of the patrons and subscribers showed themselves willing to support the new Society of Artists and a strong committee of local industrialists and artists set up the "Birmingham and Midland Counties Art-Union". For the first Autumn Exhibition they raised six hundred and fifty guineas and sponsored the continuance of the £50 prize for the best picture.

This art lottery and prize encouraged total sales to pass fourteen hundred pounds, "a very large sum indeed, considering the depression that has existed throughout the country, and in which Birmingham extensively shared." The national art journal THE ART UNION continued, "we may therefore confidently affirm, that the utility of a body of independent artists is permanently established in Birmingham."

Towards the end of the decade, THE ART JOURNAL noticed a marked improvement in the contributions to the annual exhibitions from the Society's own members and in 1849 it stated "there is no better school out of London....than the School of Birmingham....What would Birmingham be without its annual exhibition of works of art? We can as easily imagine it without a chimney!"[13]

Such notice was sufficient to attract artists like Ford Madox Brown who made a special detour in order to visit the 1849 exhibition. So as the second

half of the century dawned, the Birmingham artists felt more than justified with their decision to break with the old Society of Arts and knew that they had established a sound professional reputation both locally and nationally.

It was then, this Society which had invited the Pre-Raphaelite painters to show their works in Birmingham.

References

1. ROSSETTI, W.M. *Pre-Raphaelite Letters and Diaries* 1900 from "Pre-Raphaelite Journal May 1851"
2. AITKEN, W.C. *Journal of the Royal Society of Arts* 24th April 1874
3. LINES, S. *A Few Incidents in the Life of Samuel Lines* Birmingham 1862
4. SHOWELL, W. *Dictionary of Birmingham* Oldbury 1885 p.30. Letter from Thomas Carlyle to his brother, 10th August 1824
5. Leaflet dated October 1826 in *Collection Relating to the Society of Arts: 1814-1843* Birmingham Reference Library
6. *The Birmingham Journal* 28th October, 18th November 1829
7. *The Birmingham Journal* 19th November 1840
8. TIMMINS, S. *Birmingham and the Midland Hardware District* 1866 p.viii
9. De TOCQUEVILLE, A. *A Journey to England and Ireland* 1835
10. LANGFORD, J.A. *A Century of Birmingham Life* Vol.II Birmingham 1867 p.311
11. See MacCARTHY, F. *"All Things Bright and Beautiful" - Design in Britain 1830 TO TODAY* 1972 p.13
12. *The Art Union* November 1843
13. *The Art Journal* November 1849

CHAPTER 2

PRE-RAPHAELITISM IN BIRMINGHAM

No paintings by the young Pre-Raphaelites were available for showing in Birmingham in 1851, but in the Autumn Exhibition of 1852, the Birmingham Society of Artists welcomed a new work by Millais. It was his "Ophelia".

The London press was still hostile but the art critic of THE BIRMINGHAM JOURNAL welcomed "the erratic genius and the acute sense of observation and power of imitation manifest in the picture." He urged his readers to approach this striking work without pre-conceptions, claiming that "the independent thought, the conscientious fidelity to nature, and the chaste and pure feeling of poetry which pervades the work, demand that careful and thoughtful scrutiny should precede condemnation. If this be done, we are sure that many who come to scoff will remain to wonder and admire." The writer had seen Millais's picture at the Academy, as he continued, "this picture is hung with great judgement and is seen to greater advantage than in the exhibition of the Royal Academy."[1]

Most unusually, the normal detailed notice of the Birmingham exhibition was supplemented by a special front-page article, reasoning that "it would be unjust to the little band of earnest men who have taken to themselves the title of 'Pre-Raphaelite brethren', of whom John Everett Millais is the most distinguished member, to dispose of the first picture they have contributed to the Birmingham Exhibition in a brief paragraph among our ordinary criticisms." There followed a long, thoughtful and balanced analysis of the characteristics of "the new school", quoting fully from the offending Discourse of Reynolds and from the letters of Ruskin, concluding with the opinion that even if the Pre-Raphaelites do not form a school of their own, their influence could do nothing but good in turning artists back to "the study of nature", "correct observation", and "independent thought" to compensate for the "traditions of the schools", and the "slavish reproduction of academy models".

In 1853, another Pre-Raphaelite painting was hailed as "one of the most perfect works in the exhibition, and one that ought to be studied....with an intelligent appreciation of its peculiar beauties and its special teachings."[2] This was Holman Hunt's 'Strayed Sheep (Our English Coasts)', which

excited the admiration of the Birmingham reviewer who described it as "the marvellous sheep picture of Holman Hunt, marvellous for its literal truth, its subtle atmosphere and its artistic expression," thus anticipating by two years Delacroix's astonishment when he saw the same picture exhibited at the Paris Exposition in 1855.

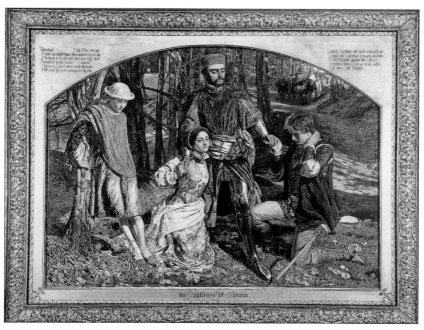

'The Two Gentlemen of Verona' 1851, by William Holman Hunt 1827-1910. Exhibited at the Birmingham Society of Artists Autumn Exhibition in 1854, purchased by Birmingham Art Gallery in 1887.

The following year, Hunt's 'Two Gentlemen of Verona' was available for exhibition, and THE BIRMINGHAM JOURNAL commented "there are more pleasing pictures in the Exhibition undoubtedly, but we question if it is surpassed by any for mental power, the knowledge of human passion and action, and for the vigour and skill over the materials of art which it displays."[3]

The 1840's and 1850's were also innovating decades in Birmingham across the field of applied design. Here too a new style had emerged to replace Neo-Classicism – it was Gothic revival. It was promoted and practised by a designer with more than just a local reputation who was very active in Birmingham. He was Augustus Welby Northmore Pugin.

Architect, author, apologist, antiquary, ardent Roman Catholic and prolific designer – Pugin had become closely connected with Birmingham from 1837 when he was appointed architect and Professor of Ecclesiastical Antiquity at St.Mary's College, a Roman Catholic seminary at nearby Oscott, and met John Hardman.

Hardman was so fired by Pugin's passionate advocacy of Christian gothic art that he re-structured his father's button-making firm into a vehicle to produce Pugin's designs. From 1844 until his death in 1852, Pugin was the chief designer for Hardman creating an enormous range of objects, mostly in richly be-jewelled metalwares in a lively and intelligent Gothic revival style.

John Hardman pre-dated William Morris in his desire to improve metalcraft techniques. He found and trained skilled workers in gold, silver and brass, and experimented, as Morris was to do, to rediscover lost processes. After many difficulties, and considerable expense, Hardman was able to create "the fondest dreams of his friend and associate, Mr Pugin."[4]

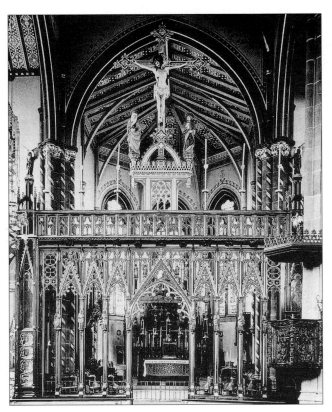

The Chancel of the Cathedral of St Chad, Birmingham 1839-1841. Designed by Augustus Pugin 1812-1852, and built by John Hardman II 1811-1867.

The magnificent Rood Screen was demolished in 1967.

As well as his prolific output for Hardman, Pugin detailed the new buildings for King Edward's School in New Street for Charles Barry in pale imitation of the work they were doing for the Houses of Parliament, and he designed many Roman Catholic churches across England and Ireland, including the cathedral of St.Chad in Birmingham and the Convent of Our Lady in Hockley, both largely financed by the Hardman family.

In 1845, Hardman added stained glass to the firm's production. Designs and cartoons were executed at the Studio of Christian Art set up by Pugin at Ramsgate, and carried out at Hardman's works in Newhall Street in Birmingham. Together, they revived the richness of the medieval techniques of stained glass to replace the fashionable painted glass windows.

A contemporary Birmingham historian noted that "Birmingham was, at the bidding of an earnest man, capable of producing things honest, truthful, noble and precious....When Hardman commenced his labours he found everything false as regards principle, and tinsel as regards ornament; for the false he substituted the true, for the tinsel he substituted the real. There are few cathedrals, churches or public buildings built according to the true principles of revived gothic architecture, in which are not enshrined some examples of his manufacture."[5]

Fellow-designer William Costen Aitken, commented of Pugin's influence on metal-working that it "WAS CLOSELY AKIN TO THAT OF THE PRE-RAPHAELITE MOVEMENT ON PAINTING. It has had the effect of making metal workers THINK, apparently for the first time for centuries."[6]

Here is one of the reasons for the Birmingham readiness to accept the pictures of the Pre-Raphaelites.

Aitken, born in Dumfries in 1817, had come to Birmingham in the same year as Pugin and quickly established a reputation as a talented industrial designer. He studied and mastered the ancient metal-working techniques being re-introduced by Hardman and in 1844 he became chief designer for the art metal-works of R. and W. Winfield in Cambridge Street and was responsible for the application of decorative glass to brass products there.

He defined the relationship of the fine artist to the art-workman as, "the mission of the artist is a high and noble one, and second only to it, the labours of the art-workman whose duty it is to elaborate, and give the works of industry – in common with fitness for their purpose – grace, elegance and beauty." He urged the need for collections of decorative and industrial art to be established in every School of Design, claiming that the French had been doing this successfully for the past hundred years, and that this accounted for the superiority of their industrial design.

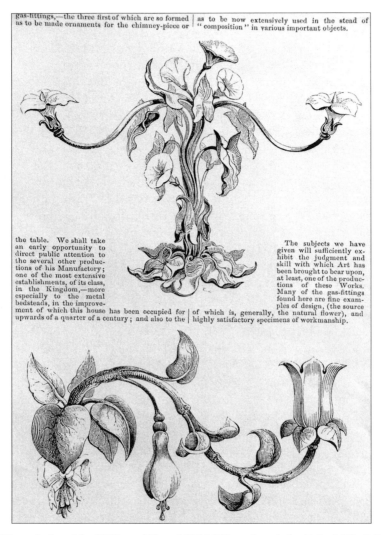

gas-fittings,—the three first of which are so formed as to be made ornaments for the chimney-piece or as to be now extensively used in the stead of "composition" in various important objects.

the table. We shall take an early opportunity to direct public attention to the several other productions of his Manufactory; one of the most extensive establishments, of its class, in the Kingdom,—more especially to the metal bedsteads, in the improvement of which this house has been occupied for upwards of a quarter of a century; and also to the

The subjects we have given will sufficiently exhibit the judgment and skill with which Art has been brought to bear upon, at least, one of the productions of these Works. Many of the gas-fittings found here are fine examples of design, (the source of which is, generally, the natural flower), and highly satisfactory specimens of workmanship.

Gas Fittings designed by William Aitken 1817-1876, and made by Robert Winfield 1810-1869, exhibited at the Birmingham Exhibition of Arts and Manufactures 1849. From the ART JOURNAL October 1849

Aitken had played a prominent role in promoting an exhibition to coincide with the second visit to Birmingham of the British Association for the Advancement of Science in 1849. It was to have far-reaching consequences for industrial design across the world and prepared the way for the great

international exhibitions of manufactured goods which became such a feature of the second half of the nineteenth century. It was held in a specially-erected temporary wooden hall in the grounds of Bingley House, in Broad Street, now the site of the International Convention Centre.

The exhibition was open for twelve hours each day, with special rates of admission for the working class from six till ten each evening. Cheap excursion trains were laid on from London, Leeds, Derby and the Potteries. Over 100,000 people eventually visited the exhibition and were remarkable for their orderly behaviour. Actively promoted by Aitken, and managed by a committee of local manufacturers, this was to be the most important exhibition of industrial design mounted in this country up to this date. It was also "fairly entitled to be considered the prototype of the 1851 Exhibition," according to THE ILLUSTRATED LONDON NEWS.

The event was strongly supported by the national art press. The stand which won the highest praise from visitors and press alike, was Hardman's for its "peculiar truthfulness of design and beauty of execution....This stand eclipses everything else in gorgeousness of detail....Collectively, we have never before seen so complete an exposition of ecclesiastical ornament, and in such thorough good taste, brought together."[7]

On September 13th, ten days after the formal opening, Henry Cole visited the exhibition in his capacity as Chairman of the London Society of Arts, and at a meeting with some of the leading exhibitors, he proposed a scheme to stage an even bigger event on a national scale in London. On November 12th, Cole shrewdly brought Prince Albert, who was the President of the Society of Arts, to Birmingham, where His Royal Highness spent three hours examining the exhibits and talking to the exhibitors. It was whilst he was in Birmingham that Albert translated Cole's proposal for a national emporium of British artefacts into his vision of a great international exhibition.

Incredibly, only eighteen months later, Queen Victoria was able to declare open the Great International Exhibition of the Works of Industry of all Nations in Hyde Park. The cast-iron prefabricated sections and the glass for Paxton's "Crystal Palace" were made in Birmingham, and Birmingham manufacturers occupied more space than any other town after London.

But although it represented a triumph of organisation, and produced a healthy profit, the Great Exhibition of 1851 only served to reinforce, yet again, what the Ewart Report had discovered and what Aitken was constantly arguing, that "in the arts of ornamentation and design, England was far behind her continental neighbours. Englishmen saw that they were no match for other countries in point of elegance and taste."[8] British

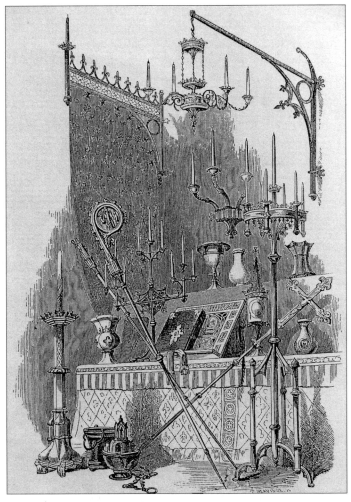

The Hardman Stand at the Birmingham Exhibition of Arts and Manufactures 1849, showing Ecclesiastical objects designed by Augustus Pugin and made by John Hardman II. From the ART JOURNAL October 1849

manufacturers were seen to be guilty of meaningless, cluttered decoration and endless borrowings against which the strength of Pugin's "Medieval Court", filled with ecclesiastical furnishings by Hardman, stood out, as at the Birmingham exhibition, as a memorable exception, along with the brassware products of Winfield's designed by Aitken.

Along with the rest of the British Isles, the Birmingham School of Design was reorganised as part of the sweeping changes introduced by Sir Henry Cole after the dismal showing of British design at the Great Exhibition. A practising designer who had assisted Cole in the organisation of the Great Exhibition was brought in to re-structure the School which had been struggling along under a succession of teachers in New Street. He was George Wallis. But he was soon recalled to London to help establish the South Kensington Museum and was succeeded by David Raimbach who was to take the renamed School of Art into new quarters. It was to become part of a grander educational scheme – the Birmingham and Midland Institute.

The Society of Artists had been prominent in the agitation for this move. In January 1853, they had staged a Festival of Literature and Art in their Temple Row Galleries at which the guest of honour was Charles Dickens. In November, Prince Albert came to lay the foundation stone for the new

The Birmingham and Midland Institute. Designed by Edward Middleton Barry 1830-1880 in 1854. The main entrance was to the extreme right of this picture. The doorway to the left opened to the School of Art stairs which gave direct access to the School of Art studios on the top floor. The gabled facade to the left was the extension designed by John Henry Chamberlain in 1876 to house the lecture theatre and extra classrooms.

building beside the Town Hall. Speaking of the Great Exhibition the Prince reminded his audience that he could not forget "that the example of such industrial exhibitions had been already set by this town....or that, to the experience so acquired, the Executive Committee of the greater undertaking in 1851 were much indebted in carrying that work to a successful issue. As Birmingham was thus foremost in giving a practical stimulus to the works of art and industry, so she is now one of the first in the field to encourage a scientific study of the principles on which those works depend for success."[9]

The School of Art moved into six studios on the top floor of the new Institute.

The leading role played by Peter Hollins in promoting the creation of the Birmingham and Midland Institute, and manipulating the removal of the School of Design from New Street to enable the artists to regain their galleries, gives some indication of the continuing position of importance Hollins occupied in the town through his capacity as Vice-President of the Society of Artists.

In 1856, the Society of Artists again welcomed work from both Millais and Hunt. In the principal gallery two paintings were hung that were instantly recognised as being, as they have remained, amongst the most powerful and memorable images of nineteenth century painting. The art critic of THE BIRMINGHAM JOURNAL was ecstatic – "to the right, that very powerful picture (which has excited much controversy) the 'Awakened Conscience' by Holman Hunt; to the left, the doubtfully true, but in some respects clever picture, the 'Blind Girl' by Millais".[10]

THE BIRMINGHAM JOURNAL devoted a lengthy article to these two pictures, and asked whether the Pre-Raphaelites had now fulfilled their mission, having successfully jolted the art establishment to "a change for the better, alike in the subjects and treatment, manipulation and colour, of the pictures sent to the Fine Art Exhibitions of the metropolis and the provinces." The article claimed that the Pre-Raphaelite pictures could never be popular with the English public because although they "speak volumes of truth", their "peculiarities" of harsh drawing and vivid colour "are all but repulsive". It praises the artists' integrity for independent thought, but warns them not to exagerate their peculiarities "for mere sake of being peculiar".

In a brief reference to Robert Braithwaite Martineau's 'Katherine and Petruchio', also showing in the 1856 Exhibition, the article gets to the heart of the matter by pointing out that Martineau has effectively copied the "external characteristics" of the Pre-Raphaelites "rather than that which is the most important speciality, the expression of feeling and sentiment."

The Autumn of 1856 was particularly rich in opportunities for the art-cognescenti of Birmingham to see a wide cross-section of current painting.

There was the annual Exhibition of the Society of Artists in Temple Row, (admission one shilling), which included Millais's 'Blind Girl', Holman Hunt's 'Awakened Conscience', Etty's 'The World before the Flood', and examples of the work of most of the leading Academicians. Around the corner in Temple Street, the Oddfellows Hall had been hired for two more exhibitions. There, for another shilling, in one room two hundred and fifty paintings by "Modern Artists of the French School" were on view, and in a second room, two hundred and eight items selected by the Glasgow Art-Union were on free exhibition hoping to tempt the visitor to buy tickets towards the ballot.

Having sampled these three exhibitions, the art-lover could then continue to Everitt and Hill's Gallery at 66, New Street, where, for sixpence, he could view three paintings by Sir Edwin Landseer RA, before proceeding to Union Passage where, at Underwood's Fine Arts Repository, he could inspect a large crayon drawing by George Richmond of one of Birmingham's more eccentric sons – the Very Reverend John Henry Newman DD. This portrait was to be engraved by John Henry Robinson ARA, and presumably Mr Underwood hoped his clients would purchase a print.

Had he chosen the right day, our art lover might have caught a glimpse of the French animal painter Rosa Bonheur, on a promotional tour of England and Scotland, when her train stopped at Birmingham to be "met by a horde of children massed round the station presenting bouquets and an address of welcome"!

She stayed for several days at Metchley Abbey in Harborne as the guest of Charles Birch and took the opportunity of visiting David Cox at his studio nearby.

The interest in contemporary French painting was expanded in the Autumn Exhibition of the Society of Artists when they showed four paintings lent by the Palais Luxembourg: 'Christ giving the Keys of Paradise to St.Peter' by Ingres; 'The Princes in the Tower' by Delaroche; 'The Defence of Paris – 1814' by Vernet; and, 'A Jewish Wedding' by Delacroix.

Despite the success of the annual exhibitions of the Society of Artists, there was still no permanent art gallery in the town, and perhaps more importantly for Birmingham, there was still no design museum. Despite fifty years of campaigning for exhibitions of industrial design, the acknowledged success of the 1849 Exhibition, and the major contribution by Birmingham's manufacturers to the Great Exhibition, there was still no permanent resource

of historical and current design material readily available to inform and educate the designer, the craftsman, the manufacturer, and the consumer in the largest manufacturing centre in the world. The reasons were entirely financial. Despite the passing of the Museums and Libraries Act in 1850 which authorised local authorities to establish buildings to house museums and art galleries by levying a local rate, there was no means to fund adequate acquisition and exhibition facilities other than from the private benefactor.

William Costen Aitken, the local designer who had played a leading role in the 1849 exhibition, had been campaigning for some time for a permanent collection of "Art applied to manufactures, where the working man may retire in the evening, from the bustle and turmoil of business, to store up in his mind that which will aid him for the coming day." For he argued that, "no town in the Empire can boast of fewer adjuncts of this kind than Birmingham; in none is there a greater necessity for what is daily more called-for – the Art-educated workman."[11]

Aitken saw the urgent need for much more than a collection of casts taken from antique sculpture. He was calling for "a permanent local museum, which shall contain.... some works by the old masters in design as applied to manufactures, with not a few of the best works of today." In other words, he was proposing a proper design museum, with a permanent collection of excellent and well-crafted objects, both ancient and contemporary, to serve as a valuable resource and stimulus for the Birmingham designer and craftsman. He had visited Paris in 1849 and warned that France spent much more on state-aided design education and museums than Britain, and that with improvements in trade and travel, Britain was losing her competitive edge. In his view, it was essential for Birmingham manufacturers, designers and consumers to have ready access to the best in design from the past, and the present.

In 1858, Aitken was given an unexpected opportunity to rectify this omission. Only two miles from the heart of Birmingham, a magnificent seventeenth-century mansion – Aston Hall – had been standing empty. It was now threatened by developers who were busily filling its former deer-park with row upon row of terraced houses between the northern boundary of the town and the still separate villages of Aston and Handsworth. It seemed to be generally agreed that the Hall would make an excellent museum, and the surviving grounds would provide a much-needed public open space for the town in the spirit of the Great Exhibition in Hyde Park. But how to proceed was less certain. There were no government funds, the Town Council procrastinated for several years, no individual benefactor

would provide the required £40,000, and the housing speculators were getting restive. A not-unfamiliar pattern. The solution was less familiar. A Committee of Working Men formed a limited company to raise share capital. Shares and donations started to accumulate, and a down-payment secured the Hall. A large glazed exhibition area – a mini Crystal Palace – was erected along the back of the Hall, and a sub-committee asked William Aitken to assemble material for a loan exhibition of art and applied design. Then, before it was paid for, the Committee boldly invited the Queen to come and open the Hall and Park to the public.

On 15th June 1858, Queen Victoria and Prince Albert arrived in Birmingham. The windows and parapet of the newly-completed School of Art offered an excellent vantage point from which to catch a glimpse of the Royal party. Inside the Town Hall, the Queen received loyal addresses, including one from the Society of Artists. At the opening of Aston Hall the Queen declared "the improvement of the moral, intellectual, and social condition of my people will always command my earnest attention; and in opening this Hall and Park today, I rejoice to have another opportunity of promoting their comfort and innocent recreation."[12]

For the official opening, Aitken assembled a comprehensive selection of historical material, contemporary painting, and current art-manufactures, as a model for a future permanent museum. It was a remarkable achievement. It was a very successful and wide-ranging display, acclaimed by the national press as worthy of comparison with both the Great Exhibition and the Manchester Exhibition. It was visited by a large number of people during the summer, and its influence had far-reaching effects. William Showell, writing in 1885, claimed that "there can be little doubt that the advance which has taken place in the scientific and artistic trade circles of the town spring in great measure from this exhibition."[13]

Back in 1849, the year in which Millais, Rossetti and Hunt, whilst still students at the Royal Academy Schools, had impudently dismissed all painting since Raphael as "filthy slosh" and declared that they would start to produce "thoroughly good pictures", William Kenrick, aged nineteen, went from Birmingham to study in London. If he had followed his initial inclination he would have enrolled at the Academy Schools and found himself a class-mate of Millais and Hunt, and might even have joined them to pore over engravings of early Renaissance paintings in Mrs.Millais's parlour in Gower Street. When his industrialist father had asked the young Kenrick what he would like to be, he had replied without hesitation, "an artist". "Think it over," his father had replied, "could you be a good artist,

not a mere amateur?" It was the honest reply to that question which took the young Kenrick to study chemistry at University College, rather than painting at the Academy Schools. Despite this setback, he was to return to Birmingham and make a long and distinguished contribution to the industrial, political, public, educational and cultural life of the town.[14]

In the summer of 1852, two schoolboys, one from Birmingham and the other from London, found themselves in the decaying grandeur of Oxford sitting for the University matriculation examinations. It was the famous first meeting of Edward Burne-Jones, aged nineteen, and William Morris, aged eighteen and it was to be the start of a life-long association of personal friendship and shared creative design that is almost unique in the history of art or design. It was also to be the start of a life-long association between the two artists and Birmingham.

This was initiated through undergraduate friendships but it deepened in later years with the discovery of shared convictions about the role of modern art in modern society. The mature Morris was to find that ideas which had been fermenting in his fertile imagination received an especially sympathetic response from his contemporaries in the political and cultural cauldron that was mid-Victorian Birmingham.

Ted "Treacle" Jones had been born at 11,Bennett's Hill in Birmingham in 1831, and whilst studying in Pugin's new Big School of King Edward's School in New Street he had been sent along to the School of Art to study the principles of light and shade under Thomas Clarke. His opinion of the schoolboy's efforts was hardly encouraging – "might do better if he exhibited more industry."[15] What would Clarke have said of the prodigious output of the mature Edward Burne-Jones?

The first links between Morris and Birmingham were forged during those formative years at Oxford, not only through Morris's growing friendship with Burne-Jones, but also through his association with a group of undergraduates who had come up from Burne-Jones' old school of King Edward's. These young men were known as the "Birmingham Set", and included R.W.Dixon, William Fulford, Charles Faulkner, Cormell Price and Harry Macdonald – with all of whom Morris was to remain closely associated in one way or another.

Burne-Jones never lost touch with his native town. He had many friends and admirers there, especially William Kenrick. He was to receive major commissions from the town and make many visits to the School of Art where his mature style was to exert a powerful influence on the work of the students.

In that fateful summer of 1852, Burne-Jones also met one of the many

sisters of Harry Macdonald who had been born a little further up Bennett's Hill in Newhall Street. The eleven-year-old Georgiana was destined to become the stalwart life-long companion of both Burne-Jones and Morris, as the loyal wife of one and the grey-eyed beloved of the other.

Another link with Birmingham was forged.

During summer Vacations, Morris was frequently in Birmingham, visiting members of the "Birmingham Set", attending their weddings, going on outings, having parties, and so on. He spent most time with Burne-Jones, who now lived with his father off the Bristol Road.

In the Long Vacation of 1855, whilst Burne-Jones and Morris were in Birmingham, Burne-Jones discovered Malory's MORTE D'ARTHUR in a second-hand bookshop in the town. Unable to afford to buy it, he was surreptitiously reading the story when Morris found him, and bought the book for him. Morris's impulsive gift was to have a profound influence on their later work.

In 1856, Morris and Burne-Jones left Oxford, no longer intending to enter the church, but determined to become artists. They moved to London, met Rossetti and Ruskin, and in the summer Vacation they returned to Oxford with Rossetti to work on the murals and decorations of the new Debating Chamber of the Oxford Union.

Burne-Jones became engaged to Georgie, and Morris met and fell in love with Jane Burden.

In 1859, Morris married Jane and asked Philip Webb to design their home – "Red House" in Kent.

In 1860, Burne-Jones married Georgie and Rossetti married Lizzie Siddal, and the three couples spent an idyllic summer decorating the Morris's new home according to Pre-Raphaelite principles. During this period Burne-Jones and Morris had less frequent contact with Birmingham although when the design partnership was created in 1861, it was another of the "Birmingham Set" who lent his name and his accountancy skills to Morris. Charles Faulkner, who was now a mathematics don at Oxford, served as book-keeper to the new decorating firm of Morris, Marshall and Faulkner, whilst his sisters, Lucy and Kate, both carried out many designs for the Firm.

That might have been the sum of Morris's links with Birmingham. However, it is a strange coincidence, that in the year that Morris and Burne-Jones started out on their chosen paths in London as architect and painter, another young artist was drawn from London to work in Birmingham. That young artist was John Henry Chamberlain and he would be instrumental in bringing both Morris and Burne-Jones back to Birmingham.

Whilst Morris and Burne-Jones had been discovering poetry and art at Oxford, the young John Henry Chamberlain had been studying architecture in London and had discovered Ruskin.

The aspiring architect had been born in Leicester and his early drawing promise led him to articles with a leading local architect – Henry Goddard, before going to London to complete his studies. But it was not to be the buildings he saw around him in London that were to help him but the latest publication of John Ruskin – THE SEVEN LAMPS OF ARCHITECTURE.

As Chamberlain read this book he felt that it had been written just for him. On the very first page, Ruskin affirmed, "Architecture is the art which so disposes and adorns the edifices raised by man....that the sight of them may contribute to his mental health, power and pleasure,"[16] and as the young man drank in the dogmatic statements scattered amongst memorable passages of flowing prose, rich in idea and imagery, opinion and advice, he was overwhelmed. The gorgeous phrases, ringing with biblical intonation, full of metaphor, sometimes so beautiful as to become pure poetry, sometimes so convoluted as to lose all meaning, sometimes punctuated by sudden shafts of certainty, "came upon him as a light in the midst of professional darkness."[17]

It was heady stuff for an impressionable young man. He read on, "Architecture must be the beginning of arts....the prosperity of our....painting and sculpture depends upon that of our architecture. Our architecture will languish.... until a universal system of form and workmanship be everywhere adopted. You will never raise it above the merest diletanttantism....unless one bold step be taken....to choose a style, and to use it universally."[18]

In the confusion of eclectic styles that marked the 1850's, this conviction was precisely what the young man had been looking for. Ruskin's call for a consistent, universal style must have seemed so right.

Chamberlain absorbed the development of Ruskin's thesis in THE STONES OF VENICE, published in instalments between 1849 and 1853, in which Ruskin defined the style he believed was the only one suited to bring about the rebirth of British architecture and design. In this most seminal work Ruskin pleaded for the introduction of "the Gothic form" into architecture,...not merely because it is lovely, but because it is the only form of faithful, strong, enduring and honourable building, in such materials as come daily to our hands," and he explained more precisely that "Gothic is not only the best, but the ONLY RATIONAL architecture, as being that which can fit itself most easily to all services, vulgar or noble. Undefined in its slope

of roof, height of shaft, breadth of arch, or disposition of ground plan, it can shrink into a turret, expand into a hall, coil into a staircase, or spring into a spire, with undegraded grace and unexhausted energy; and whenever it finds occasion for change in its form or purpose it submits to it without the slightest sense of loss either to its unity or majesty – subtle and flexible like a fiery serpent, but ever attentive to the voice of the charmer."[19]

How much more compelling and seductive an image for an aspiring young architect, to respond to the summons to become a charmer of snakes, rather than a breaker of horses, or a tamer of lions.

Ruskin continued his relentless, idiosyncratic reasoning. "And it is one of the chief virtues of the Gothic builders, that they never suffered ideas of outside symmetries and consistencies to interfere with the real use and value of what they did."

Not for Ruskin the dull monotony of the eighteenth century facade obscuring the function of the internal spaces, nor the mathematical correctness of classical column and architrave. He preached the need for savageness, changefulness, naturalism, grotesqueness, obstinacy, generosity – strange language and even stranger concepts that did not feature in the normal conversation between everyday architects and their clients.

More specifically, rather than Pugin's scholarly revival of French Gothic idioms, Ruskin claimed the high point of the Gothic style to have been realised in Venice, and urged architects to adopt therefore a "Venetian-Gothic" style as the "scrupulous, earnest and affectionate" form for their use.

Chamberlain's doubts were swept away. He now knew precisely the direction his art – his life's work – would take. He was going to create a new architecture that would transform the face of Britain and contribute to the "mental health, power and pleasure" of his fellow-countrymen.

"From this time to the present," he claimed, thirty years later, "there had not been a year, a month,a week, perhaps scarcely a day of his life in which he had not felt strengthened and bolstered by the feelings derived from the reading of Mr Ruskin's works and the guidance which he had obtained therefrom."[20]

Chamberlain set out for Venice to see for himself the siren-city which seems able to seduce generation after generation of sun-starved English artists. He spent many months there with Ruskin's books in one hand, making dozens of detailed drawings with the other, as he carefully analysed the crumbling palaces, storing up the secrets of their decaying beauty, discovering with Ruskin the delight in detail and the dedication of long-dead craftsmen. He was not disappointed.

He returned from Italy in 1856 and was drawn to practise in Birmingham quite fortuitously because an uncle offered him a commission to design a shop and warehouse for his expanding ironmongery business there. Chamberlain wasted no time in putting Ruskin's ideas and his own memories of Venice to the test.

"Thanks to the admirable taste of Mr J.H.Chamberlain, architect, an example was this year given of the way in which beauty of design may unite with utility, and excellence of execution with business requirements, in the premises of Messrs Eld and Chamberlain in Union Passage. The building is externally and internally beautiful and is one of the architectural adornments of the town."[21]

This was the enthusiastic response of J.H.Langford, the chronicler of Birmingham, but it must be admitted that his impression was coloured by the fact that he was also a fervent Ruskinian. His opinion was not shared universally by his fellow-citizens.

Chamberlain designed a second building. This was a private villa for his uncle's business partner which he erected in the heart of the Calthorpe Estate

'Shenstone House', Ampton Road, Edgbaston. Designed by John Henry Chamberlain 1831-1883, in 1858 for John Eld.

in Edgbaston. This exclusive development consisted of discreet stuccoed villas, square-cut, respectable and redolent of Regency elegance and under-statement, nestled in bosky privacy, to windward of Birmingham.

Mr. Eld's "Shenstone House", in Ampton Road emerged in pink, white and blue brick, with arched windows dressed with stone, decorated with brilliantly-glazed tiles and topped by a steeply-sloping roof of gaily-patterned slates.

This uninhibited exploitation of a "Venetian-gothic" style caused a sensation amongst its reserved Neo-Classical neighbours. The dazzling design adhered faithfully to the concept of Ruskin's "Lamp of Truth", with its daring polychromatic interplay of brick, stone and tiles, and its confident external elevations with their vertical groupings of windows and clear indications of the internal functions of the house.

At a stroke, in these two buildings, the twenty-five-year- old architect demonstrated how well he had grasped the principles set down by Ruskin, and how much he had absorbed from his studies in Venice. It was a confident statement, and effectively heralded the style which would be adopted to clothe and express the civic crusade across Birmingham a decade later.

"Shenstone House" is quintessentially Pre-Raphaelite. It is full of symbolism, delighting in pattern and textural richness, owing allegiance to the past but placed firmly in the present. It exploits modern materials, and modern technology. It is not antiquarian – it could never be mistaken for a medieval, or even a Venetian house. It is modern, it is a "thoroughly good house".

It is significant to note that Chamberlain's exuberant design for "Shenstone House" pre-dates Philip Webb's "Red House" for Morris. Webb's design owes more to Street than to Ruskin. More restrained and with less external decoration, "Red House" has more variety in its silhouette and massing.

But Chamberlain's buildings were too innovatory. There was nothing else like his work in the whole town. Birmingham was given over to down-to-earth buildings derived from eighteenth-century types, themselves derivations of renaissance models, "what....might be called the rectangular style – the houses being mainly straight-sided boxes of brick or stone with regular apertures for doors and windows."

No medieval domestic buildings had survived in the town, and all the churches were eighteenth-century or recent re-constructions. St.Martin's-in-the-Bull Ring had been entirely rebuilt in a red-brick Queen Anne style except for its spire, St.Philip's was a restrained Baroque exotic, and although

Pugin had built St.Chad's church in the 1830's, later to become the Roman Catholic Cathedral, even its exterior was in a restrained monochrome brown-brick form of Gothic, owing more to Northern Europe than to Venice. Pugin's detailing of King Edward's School was in a spare Tudor style, and its intended central oriel and clock tower were never built. J.J.Scoles had begun St.George's church in Edgbaston in a rather timid pre-Tractarian Early English style using cast-iron columns, and the Queen's College in Paradise Street by Drury and Bateman displayed a vaguely Elizabethan style with Oxbridge references. So, Chamberlain's ornate shop front and exuberant villa were quite exceptional.

Despite the notoriety, or presumably because of it, further work did not materialise. A few commissions for work in his native town of Leicester, and some estate houses at Hagley for Lord Lyttelton did not provide sufficient security for the newly-married young architect, and like many other young couples at the end of the 1850's, the Chamberlain's were considering emigrating as there was some promise of work on the new cathedral at Christchurch, New Zealand. (This was a period of mass-emigration to North America, Australia and New Zealand. Compare Ford Madox Brown's memorable record of this in 'The Last of England' painted in 1852-55 and now in the Birmingham Art Gallery.)

However, he obtained a partnership with William Martin and continued his campaign to persuade potential clients to accept variations of "Venetian-gothic" as the style best fitted to represent a modern and forward-looking Birmingham.

Meanwhile, on their return to New Street in 1858, the Society of Artists cleaned and re-decorated the galleries, hanging the Great Room with crimson draperies and picking out the mouldings in gilt. The press re-discovered that "there is not, we believe, in England a finer exhibition room than this, its circular form distributing the light equally on all pictures on its walls."[22] The Autumn Exhibition showed over six hundred paintings including some of the best "breezy pieces" of David Cox. These were to be his last contribution. He died in June 1859.

There were other changes in the Society. Samuel Lines retired as Treasurer and was elected an honorary Member. Alan Everitt became Secretary in 1857 in succession to J.Eaton Walker. Frederick Henshaw replaced Lines as Treasurer, Hollins continued as Vice-President, and Sir Charles Lock Eastlake PRA, served as Honorary President from 1850 to 1865.

Notable in 1860 were works by Turner and Maclise, in 1861 works by Landseer, Millais and Henry Wallis, in 1862 some outstanding Turners lent

by Joseph Gillott the millionaire pen-maker. He had a large collection of modern English painting at his Edgbaston home. William Etty sometimes painted there, and Gillott knew both Turner and Cox, but he didn't care for the Pre-Raphaelites.

The work of the local artists drew most praise in 1863, especially the landscapes of Henshaw and Burt. In 1864, Gillott lent another selection from his collection and the 1865 exhibition was dominated by two more early Pre-Raphaelite pictures.

They were Holman Hunt's 'The Hireling Shepherd', painted in 1851, and the picture which had so upset Dickens – 'The Carpenter's Shop', or 'Christ in the House of His Parents', which Millais had first exhibited in 1850.

THE BIRMINGHAM JOURNAL commented "....we fall in with one of Millais's earliest and ablest pictures, 'The Sacred Carpenter's Shop' – once the subject of endless controversy in that chattering coterie which calls itself "the world of Art", The writer admired "it's intense realism, it's quaint homely pathos, the remarkable technical skill, even while we doubt whether Mr Millais should have made the Virgin so ugly, or Joseph so terribly commonplace, or the Child so like the son of a Jewish handcraftsman."[23]

Of 'The Hireling Shepherd' he doubted the need for such abstruse symbolism, but praised "the fact that one so completely loses sight of the paint, the semblance of reality is so well counterfeited that it is very hard to understand that we are not spectators of an actual scene....the painting is as bright and fresh as though it had just left the easel."

In 1865, the Society decided to hold two exhibitions each year: a Spring Exhibition to be devoted to watercolours, and an Autumn Exhibition of oil paintings. Rather cautiously, it was planned to confine the first Spring Exhibition to the Great Room, but the response from hopeful exhibitors was so great that eventually 736 pictures went on show throughout the galleries.

THE ART JOURNAL reported, "Private collectors have been liberal, artists have been willing, and the result is a collection of water-colour drawings equal to that of the Manchester Art Treasures in 1857, the English Department of the International Exhibition of the Fine Arts in Paris in 1865, and but little inferior to the assemblage of the same class of works in the Exhibition of 1862."[24]

The exhibition ranged from De Wint to Birket Foster, from Sandby to William Hunt, and included some excellent work by the Birmingham members following the example of Lines and Cox, and was dominated by some fine Turners. The two exhibitions of 1866 attracted a great rise in the number of visitors and total receipts from sales were up by £1500 on the

previous year. The following year saw two more highly successful exhibitions seen by over 35,000 visitors with sales of £4,458.

Another notable collection of English water-colours was assembled for the Spring show from which the Mayor, George Dixon, purchased Henshaw's 'Old Oak Tree in the Forest of Arden' for £100 and presented it to the proposed Corporation Art Gallery. The Autumn exhibition showed a larger proportion of pictures submitted direct from their artists, and less lent by collectors, although a notable exception was the long-awaited Millais which the Society had first tried to borrow for exhibition in 1851. It was 'The Return of the Dove to the Ark' which was hailed as "one of the finest examples of the Pre-Raphaelite School".[25]

Peter Hollins shrewdly sought to capitalise on the success of these exhibitions by seeking royal patronage. The Vice-President saw his opportunity when his friend and patron, the Earl of Bradford, became Lord Chamberlain to Queen Victoria in 1868. Hollins asked J.T. Bunce to prepare a suitable memorial to Her Majesty which he took to the Earl, who presented it to the Queen on the 14th July. Three days later the Queen's secretary communicated her reply to the Earl, "that the Society shall in future be styled The Royal Birmingham Society of Artists".

The Birmingham artists were jubilant at this accolade for their Society. The President of the Royal Academy, Sir Francis Grant, who had served the Birmingham Society as their honorary President since 1866, wrote to Hollins declaring that he would be proud to continue in office, and that he would ensure that "the members of the Royal Academy shall give their best support to their Royal Cousin at Birmingham."[26]

From this year the elected members were entitled to use the affix of RBSA. THE ART JOURNAL acknowledged that the Royal Birmingham Society of Artists was "one of the most prosperous and most useful institutions in Birmingham....artists and the public should know that the sale of works in these rooms very far exceeds those of any exhibition in the provinces."

The two exhibitions of 1868 attracted nearly 40,000 visitors and sales amounted to more than two thousand pounds.

References
1. *The Birmingham Journal* 11th September 1852
2. *The Birmingham Journal* 1st and 15th October 1853
3. *The Birmingham Journal* 16th September 1854
4. LANGFORD, J.A. *Modern Birmingham and Its Institutions* Vol.II Birmingham 1873 p.298
5. Ibid.

6. AITKEN, W.C. *The Revived Art of Metal-Working in Medieval or True Principles* p.538 in TIMMINS, S. *Birmingham and the Midland Hardware District* 1866

7. *The Illustrated London News* 15th September 1849

8. *The Works of the Eminent Masters* Vol.I p.102 1854

9. LANGFORD, J.A. *Modern Birmingham and Its Institutions* Vol.II p.505 Birmingham 1873

10. *The Birmingham Journal* 30th August and 13th September 1856

11. *The Art Journal* November 1850

12. LANGFORD, J.A. *Modern Birmingham and Its Institutions* Vol.II p.143 Birmingham 1873

13. SHOWELL, W. *Dictionary of Birmingham* Oldbury 1885 p.68

14. DEBENHAM, C. *Recollections* Unpublished MS. c.1910

15. BURNE-JONES, G. *Memorials of Edward Burne-Jones* Vol.I p.28. 1912

16. RUSKIN, J. *The Seven Lamps of Architecture* Chap i. 1849

17. *Birmingham Daily Post* 22nd February 1879

18. RUSKIN, J. *Op.Cit.* Chap vii

19. RUSKIN, J. *The Stones of Venice* Vol.II Chap vi 1853

20. *Birmingham Daily Post* 22nd February 1879

21. LANGFORD, J.A. *Modern Birmingham and Its Institutions* Vol.I p.392 Birmingham 1873

22. *The Art Journal* October 1858

23. *The Birmingham Journal* 30th September 1865

24. *The Art Journal* June 1865

25. *The Birmingham Journal* 17th August 1867

26. HILL, J. and MIDGLEY, W. *The History of the Royal Society of Artists* Birmingham 1928 p.49

CHAPTER 3

PRE-RAPHAELITISM AND THE CIVIC GOSPEL

The high profile of the Royal Birmingham Society of Artists contributed to the spirit which fired the emerging civic consciousness throughout the 1860's.

Samuel Timmins, the Birmingham historian who was himself involved in the events of these stirring years, singled out three of his contemporaries to whom he particularly attributed the articulation of a new vision for Birmingham at this time.[1] Yet none of Timmins's trio were politicians. They were a designer, an architect, and a preacher.

The designer was William Aitken, who, as already seen, was both a leading industrial designer and an energetic apologist for better design in artefact and environment through improved design education.

The architect was John Henry Chamberlain. He too, pursued a dual path as practitioner and apologist. He was to give form to the new vision through his Ruskinian architecture and interior design and played a crucial role in the leadership of several major cultural and educational institutions.

The preacher was George Dawson. For many years he had been identified as the leading advocate of a dynamic philosophy for municipal regeneration which became known as the "civic gospel".

Dawson had come to Birmingham in 1844 as pastor to the Mount Zion Baptist Chapel. His unorthodox views soon led to a move to a new church in Edward Street that was to become famous as "George Dawson's Church of the Saviour". From 1847 to 1876, this non-sectarian church provided Dawson with a platform from which to expand his vision of what a modern city might become, and of the responsibilities of the inhabitants of that modern city to themselves, to each other, and to their city. He saw the need to create a new morality for the modern manufacturing city. Through the industrial grime and smoke he believed that Birmingham could become a "New Jerusalem". The practical implementation of the civic gospel could create a better world for all men, women and children, catering for their spiritual and physical needs, giving homes and hospitals, providing educational opportunity, and real re-creation of mind and spirit through "intellectual

cultivation and refinement". In his civic utopia a vital role was cast for the visual arts which were charged with the responsibility to create a better environment of architecture and artefact which would offer every individual citizen enrichment and pleasure, and make men glad in their living.

Because of Birmingham's long tradition of radicalism and Nonconformity in religious belief and practice, the existing religious bodies were receptive to Dawson's ideas and in the total absence of state or civic involvement, they were already the most flourishing seedbeds for community action, especially in the areas of philanthropy and adult education. Other Birmingham pastors like R.W.Dale and H.W.Crosskey took up Dawson's views. There was an extraordinary unanimity between the religious bodies of Birmingham in their support for Dawson. Nonconformist, Anglican and Roman Catholic churchmen were willing to forget their doctrinal and sectarian differences, and to enter public and political life with the mission to transform their grimy city into something approximating to the City of God on earth.

This was the stimulating intellectual vortex into which William Aitken was drawn. He recognised that Dawson's preaching was reinforcing the value of pride in individual craftsmanship. Aitken persistently argued that improvements in the environment, that is the man-made world of industrial design, could only emerge through better design education and informed knowledge of good design for both the designer and the consumer. He believed that this would be brought about mainly through easier access to examples of good design in museums.

The changes in Birmingham which Dawson's civic gospel brought about in the 1870's were not simply a change of management engineered by a new set of local politicians. The transformation of Birmingham was realised by designers like Aitken, and architects like Chamberlain. Building on the work of Lines and Hollins, they had insinuated the example of Pugin, the theories of Ruskin, and the ideals of Pre-Raphaelitism into the civic gospel. They helped to reinforce the political revolution through architecture, art and artefact, and they helped to create the educational and cultural institutions to enable the revolution to become established and grow.

When other opportunities for the discussion and dissemination of ideas did not exist, the Nonconformist chapels and debating societies assumed great importance. The Birmingham and Edgbaston Debating Society flourished during the 1860's. Topics of current political, economic, social, educational, moral, theological and artistic concern were hotly debated by the rising new middle-class men of Birmingham with Dawson as their acknowledged mentor. In 1861, at the age of thirty, John Henry Chamberlain

was elected President of this Society. He was succeeded in this office the following year by the man who was to become the brightest star in this galaxy of Birmingham men, his namesake and intimate friend (although no relation), Joseph Chamberlain, then aged twenty-six.

Towards the end of the 1860's, these young men began to realise that perhaps a strong and able Town Council might do almost as much to improve the conditions of life in the town as Parliament itself. They talked of "sweeping away streets in which it was not possible to live a healthy and decent life," but it was the subsequent step of their municipal mission that marked these men as having absorbed the aesthetic implications of the philosophy of the civic gospel reinforced by Aitken and Chamberlain during their discussions. After first tackling the enormous practical issues which were necessary to enable a large conurbation to exist, they were going to press on and create a range of facilities and amenities that would make the lives of those living in the conurbation worth living. They talked of "making the town cleaner, sweeter, brighter; of providing gardens and parks and music, of erecting baths and free libraries, an art gallery and a museum," and, then the ultimate objective, "sometimes an adventurous orator would excite his audience by dwelling on the glories of Florence, and of other cities of Italy in the Middle Ages and suggest that Birmingham too might become the home of a noble literature and art."[2] It might even become "the most artistic town in England."

The challenge certainly required imagination, for mid-nineteenth century Birmingham had little in it to suggest to the ordinary man-in-the-street that he was living in a latter-day Florence. There had been decades of political stagnation during which Birmingham had somehow survived with no effective government at all. The town was currently administered by a cautious group of councillors which had been elected principally for its promise to keep rates down. One by one, the "Dawson men" graduated from the debating society and the chapel and took up the challenge laid down by Dawson and Dale to serve their town by entering the Town Council; Thomas Avery in 1862, George Dixon in 1864, William Harris (an architect) in 1865, George Baker and Jesse Collings in 1867, Joseph Chamberlain in 1869 and William Kenrick in 1870. The incoming councillors, succcessful in business or the professions, were fired by a sense of moral duty towards their town and were big enough to face the enormous expenditure involved in the provision of proper sewage disposal and fresh water, clean streets and public amenities. It was nothing less than a bloodless revolution which had been engineered from above by the exploiting class,

rather than through agitation from below by the exploited class.

Throughout the 'sixties, the Dawson circle extended its influence as its members continued to campaign for reforms both inside and outside the Council chamber. Whilst the arguments over public spending on sewage disposal dragged on, one of their first acts was to persuade the sluggish Council to complete the purchase of Aston Hall and to establish a Free Library and Art Gallery.

An excellent central site was secured beside the Birmingham and Midland Institute, opposite the Town Hall. William Martin produced a design in an Italianate style which reflected the proximity of the Institute and the Town Hall.

The Lending Library was formally opened by George Dawson on 6th September 1865, to coincide with the opening of the Congress of the British Association in Birmingham, and on 26th October 1866, the Reference Library was opened – the first in the country where the cost of the building, and the purchase of the books, had been provided entirely from the rates.

A parallel Industrial Exhibition was organised by Aitken in an exhibition hall built in the garden of Bingley House.

Dawson was also the prime mover to establish a permanent Shakespeare Library in the town. Aided by Samuel Timmins and John Henry Chamberlain he assembled the finest extant collection of Shakespearian literature. It was housed in a lofty purpose-built room designed in a suitably Pre-Raphaelite "Elizabethan" style by Chamberlain. (This room has been incorporated into the present library complex.)

The nucleus of a public art collection was assembled. Peter Hollins presented his marble bust of David Cox; Samuel Thornton, a former Mayor, gave an enormous cast-copper statue which had been found during excavations for railway sidings at Sultanganj in 1861; and Charles Cope, John Jaffray and Peter Hollins presented a large painting of 'Dead Game' by the recently-deceased Birmingham artist Edward Coleman.

At last, a Corporation Art Gallery was opened on 1st August 1867. It consisted of only one room, seventy feet by thirty feet, nevertheless it received 35,000 visitors in the next five months. It exhibited fifty-six paintings, of which only about a dozen belonged to the museum, including several which had been placed on permanent loan from the Society of Arts.

In 1868, George Wallis sent a display of applied art from South Kensington, and in 1869, William Aitken organised a loan exhibition of Indian crafts which he hoped would encourage Birmingham manufacturers to learn from the principles involved, and not lead to the mere imitation of

stylistic motifs, an axiom he had constantly urged in connection with European medieval crafts. Nearly 200,000 visitors thronged through the little gallery to see this exhibition.

By 1870, Birmingham's artists were in an untypically strong position in their community and several were playing leading roles in the major art institutions.

The Royal Birmingham Society of Artists was still ably headed by Peter Hollins. The Birmingham and Midland Institute had been revitalised under the Chairmanship of John Henry Chamberlain, who was to consolidate his grip by also becoming Chairman of its constituent School of Art in 1874.

In April 1871, in support of the town's new art gallery, the Corporation established a Public Picture Gallery Fund following the gift of £3,000 from the glass manufacturer Thomas Clarkson Osler. The Trustees consisted of prominent businessmen sympathetic to the arts, amongst whom were William Kenrick and Frederick Elkington, but significantly, the donor nominated two leading artist-designers – William Costen Aitken and John Henry Chamberlain.

The first painting the Committee funded was 'A Condottiere' by Frederick Leighton. The following year John Brett's 'A North-West Gale off the Longships Lighthouse' was purchased from the RBSA Autumn Exhibition. (As the artist was a close friend of Chamberlain, did he influence their choice?) This precisely-observed study of waves, shows Brett under the influence of Pre-Raphaelitism and Ruskin, and had just come, unsold, from the Royal Academy.

To have included practicing artists on such a Committee would never have been countenanced in Manchester, or even in Liverpool, where despite the support of contemporary art especially of the Pre-Raphaelites, local artists never attained sufficient status or influence. Throughout the nineteenth century, this situation was found in the leading English towns, whether ancient or modern. In Birmingham it was not so much that the middle class condescended to patronise artists but that the artist and the designer had already attained middle class stature. They already lived next door, in Edgbaston and Handsworth, so that the manufacturer and the designer, the councillor and the artist, and their families, were already associating on equal terms in this class-ridden society.

Alongside the rising young industrialists, Lines and Hollins, Wallis and Raimbach, Aitken and Chamberlain, were accepted on equal terms and were in a powerful position to make positive contributions to the debates which infused the political activity. In these discussions, they were accepted as

experts, with professional knowledge in all matters of art and design. They were able to urge that architecture, art, and design, should provide visual expression for the philosophy of the civic gospel. Beside the hoped-for social reforms, the artists urged the potential city fathers to find a place for the visual arts in the streets, in the home, in the work-place, in public parks, in public buildings, and in galleries of art and design. Their dream was that, as Birmingham became the seed-bed of a new art – the home of a second renaissance at the hub of the British Empire – the Workshop of the World would become the Florence of the North.

Were there common factors among these new civic leaders as they emerged from their earnest debates?

The answer is an emphatic "Yes!"

A "Dawson man" was most likely to be a Nonconformist in religion and a radical in politics. He would be well-educated, but his education was more likely to have been idiosyncratic, modern and progressive, even self-acquired, and to be indebted more to the Bible and to contemporary writers like Carlyle and Ruskin, than to the Classics. He was prosperous, frequently being the second-generation of the rising new urban middle class. He cared for the arts, but preferred new buildings to old, contemporary architecture to that of the previous century. In painting he inclined towards realism rather than romanticism, admiring the brightly-coloured representations of modern life or moralising story of the Pre-Raphaelites rather than the brown hues of earlier paintings of Greek myth or legend. He was proud to accept artists and designers as professional men of equal standing to himself, whether in his business dealings, his philosophic debates, his political activities, or as personal friends and neighbours. He affected a deep responsibility for his less-fortunate fellow-men. He participated actively in public life, whether in the chapel, in the Sunday school, in the debating society, on the committee of some cultural or philanthropic society or one of the many action-committees, or in the Council chamber. So, by deduction, he had probably been born into one of the families of Chamberlains, Kenricks, Cadburys, Bakers, Rylands, Martineaus, Beales, and so on, who made up the close-knit Nonconformist community which dominated the public life of Birmingham's new middle class.

William Kenrick was the archetypal Dawson Man. Prosperous and successful as a third-generation holloware manufacturer, Kenrick was a Unitarian and well-educated, and was related to most of the leading Birmingham families. He wrote poetry and painted; he collected contemporary art; he entertained politicians and artists in his Pre-Raphaelite

home designed by Chamberlain and decorated by Morris; he was particularly friendly with Burne-Jones. He entered public life to serve on the Town Council; becoming Alderman and Mayor; he was elected to Parliament and appointed to the Privy Council. But most of all, he relished his role as Chairman of the Museum and School of Art Committee.

From 1870, members of the Dawson circle dominated the Council and its sub-committees, and when Kenrick's brother-in-law, Joseph Chamberlain, was elected Mayor in 1873 he declared unequivocally, "the town shall not, with God's help, know itself," and by 1885 the Birmingham of 1865 would indeed not have known itself.

Twice re-elected, Joseph Chamberlain initiated three brief years of incredible activity. Treating the position of Mayor as that of a managing director, his punctilious and incisive leadership saw the town move to the collective economy and principles of municipal socialism. Two principles under-pinned Chamberlain's civic reform. The first was his ability to exploit the power of the Town Council as an autonomous local parliament. The second was to apply the principle of public ownership through municipalisation.

By August 1875, he had won over the Town Council, obtained the necessary Parliamentary Acts, and used the power of the Courts, to thrust aside entrenched opposition and bring about the public ownership of Birmingham's water, sewerage, and gas companies. This brought immediate financial profits to the town as well as obvious benefits in improved standards of health and hygiene. Having appropriated these essential services, Chamberlain pushed through a more controversial idea – the Birmingham Improvement Scheme.

Chamberlain proposed to take advantage of new legislation which granted powers to Councils to buy up areas of housing deprivation. By demolishing a notorious district of slums in the very heart of the town the opportunity could be seized to construct a grand new Parisian-style boulevard which would extend for over a mile from New Street railway station to Gosta Green. This symbol of civic renaissance would be called Corporation Street and sport spacious shops, elegant offices and hotels.

Joseph Chamberlain resigned as Mayor in 1876 upon his election to Parliament, summing up what had been achieved in the famous phrase, "I think I have almost completed my municipal purpose....the town will be parked, paved, assized, marketed, gas and watered, and IMPROVED – all as a result of three years active work."[3]

Three days before he resigned, Chamberlain expressed the municipal ideal

– "I have an abiding faith in municipal institutions, an abiding sense of the value and importance of local government," and then he pin-pointed the importance he attached to the corporate image presented by these municipal institutions. "I desire to surround them by everything which can mark their importance, which can show the place they occupy in public estimation and respect, and which can point to their great value to the community."[4]

Here we have Joseph Chamberlain acknowledging the importance of the symbolic function of public buildings and public institutions. He recognised that they should be seen as focal points of municipal pride and achievement, as the outward symbols of the municipal revolution, as people's palaces expressing and containing the potential for improving the health and educational opportunity for all. He had grasped just how much the municipal gospel needed the visual arts to realise, and then to enrich, each new civic project.

Joseph Chamberlain was the political figurehead for the programme of reform but he was complemented in the areas of the civic renaissance concerned directly with the visual arts, by his close friend, John Henry Chamberlain. He was the architect who, almost single-handed, created a civic iconography peculiar to Birmingham. It was not "art for art's sake", or, primarily, art as the symbol of the town, but art in the service of the people. As he himself put it with devastating simplicity, "there is no reason why all building should not be Architecture."[5]

Chamberlain's most visible impact across the town was created by the varied ventilation towers rising from the new Board Schools, following the 1870 Education Act. In designing over thirty new schools he seized the opportunity to put Dawsonian, Ruskinian, and Pre-Raphaelite principles into practice by creating a house-style which ably symbolised this civic action as a moral and democratic, as well as an educational crusade. THE PALL MALL GAZETTE approved, "In Birmingham you may generally recognise a Board School by its being the best building in the neighbourhood....with lofty towers, gabled windows, warm red bricks and stained glass. The best of the Birmingham Board Schools have quite an artistic finish."[6]

It was obviously the plan of these radical Nonconformists, that each district should evolve around, and focus towards, its local Board School, just as the medieval village had clustered around its parish church. With educational opportunities available, and free, to all children, and with evening classes open, and free, for adults, the local Board School was intended to be the gateway to opportunity, the secular heart of each

community, as well as the constant physical symbol of the munificence of municipal provision.

John Henry Chamberlain also had overall responsibility for the Birmingham Improvement Scheme and personally designed several of the facades along Corporation Street. His buildings were intended to reflect the builders' and the craftsmens' joy in their work, and to inspire the user and the passer-by alike to react and to respond. For Chamberlain "delight in the beautiful was not a refined form of self-indulgence; it was associated with the most robust virtues, it was a pursuit of human perfection," and in true Pre-Raphaelite fashion, "for him there was no beauty where there was no truth and the fairest form of beauty was goodness."[7]

Although there were other architects at work in these years of reconstruction, there is no doubt that it was Chamberlain's taste which led the field in the 1870's. His Venetian-Gothic, which had surprised the citizens in the 1850's, was now accepted as symbolising all that was most progressive and tasteful. His influence could be seen along many streets throughout the Jewellery and Gun Quarter and the spreading commercial centre as new banks, offices, shops and workshops were erected with decorative facades that would have been at home by any Venetian canal. He designed public buildings for the new civic needs of the town. His distinctive style became the outward symbol of the municipal revolution, bestowing instant recognition on each new civic achievement, be it a board school, a pumping station, a branch library, public baths, a hospital, or wholesale markets. All paraded the bright red brick of revolution and the pink terracotta symbols of municipal pride. (Fellow-architect Baillie Scott called it, less kindly, "a scarlet fever of red brick"!)

The terracotta work was carried out to Chamberlain's design by Joseph Bardfield in true Pre-Raphaelite fashion. "....in all he did there was evidence of close and affectionate study of natural forms, especially in foliage and birds, in the representation of which he had almost unrivalled feeling."[8]

What is all the more extraordinary, is that Chamberlain managed to champion the style more usually associated at the time with the Tory aristocracy. For example, during the 1860's, no less a Birmingham Tory than Lord Calthorpe had asked Samuel Teulon to remodel his Hampshire country house – Elvetham Hall, not in a Classical idiom but in a most extreme multi-coloured Venetian Gothic style; and only a few miles south of Birmingham, wealthy land-owner E.P.Shirley commissioned John Prichard to do the same with Ettington Park; whilst it was the Conservative Town Council at Northampton which had awarded the competition for its new Town Hall to

a similar design by E.W.Godwin. All three of these buildings were expressed in the gaudy polychromy favoured by Ruskin. Chamberlain had long regarded Classical styles as "Exotic", and managed to convince his Liberal clients that his version of Venetian Gothic was ideally suited to fit the needs of Birmingham's new buildings!

In 1870, the centre of Birmingham had still been composed of small-scale, square, stuccoed facades above which towered the fluted columns of the Neo-Classical Town Hall. This was not a civic building, having been erected in 1832 to stage the hospital Music Festivals and house public meetings.

In 1871, a competition was announced for the design of council buildings with the young Gothic-revival architect Alfred Waterhouse as the assessor. Surprisingly, when Mayor Joseph Chamberlain laid the foundation stone for the winning design in 1874, it was for a Council House in a Classical style. The entry of his friend, John Henry Chamberlain, had been expected to win, but it was rejected in favour of a florid Renaissance design by Yeoville Thomason, another Birmingham architect who, it appears also had strong family and political connections.

A formerly unkempt area behind the Town Hall was now bordered by the Midland Institute and the side elevation of the new Council House. These three were in a variety of Classical styles. However the Gothic camp triumphed when Mason College was constructed along the north side of the burgeoning square between 1875 and 1880. This was financed by the wealthy pen-maker Josiah Mason, and designed by yet another Birmingham architect, Jethro Anstice Cossins. Cossins also designed the adjacent Liberal Club, again in Gothic, but in a lighter, more Flemish pink-brick variation.

John Henry Chamberlain finally added his contribution to the new square by extending the Midland Institute and enlarging the Free Library. He added a lecture theatre and classrooms to the west of the Institute, behind four great Gothic arches, and to the north, he expanded the Library with a Reference Room of immense proportions rivalling a cathedral in its apsed and aisled magnificence, which was approached by way of a grand iron staircase. The Edmund Street facade for this extension was in an extravagent Lombardic round-arched Gothic, glittering with glass mosaic and ceramic roundels.

Following Joseph Chamberlain's translation to Parliament in 1876, it was proposed to erect a monument at once to commemorate his outstanding municipal work. George Dawson had died in the same year and a memorial was needed to recognise his contribution. These monuments were to be erected in the newly-named Chamberlain Place and to be designed by John Henry Chamberlain. He totally ignored the surrounding visual references to

a Roman Forum and characteristically found his model in the Middle Ages.

For Joseph Chamberlain, he produced a Pre-Raphaelite conceit of a fountain fit for a medieval marketplace. It featured a crocketted spire in a decorated Gothic, with gabled blank windows containing mosaic inserts and a portrait medallion by one of the original Pre-Raphaelite brothers – Thomas Woolner, (who had returned from Australia.)

For Dawson, he created a Gothic shrine, more suited to a civic necropolis than a civic centre. Under another mini-spire, he placed a life-size statue of Dawson, also by Woolner, dressed in a nineteenth century frock coat.

The Tory press howled. Both monuments were severely criticised. Dawson's statue was considered a bad likeness, and had to be re-carved at Chamberlain's expense. The canopy lacked the grand scale of either the Albert Memorial in London, or the Scott Memorial in Edinburgh. The fountain below Woolner's medallion provided Chamberlain Place with the nick-name of "Squirt Square" for those less in sympathy with this growing assembly of Liberal demi-gods.

As well as carrying out a considerable body of public building, Chamberlain could hardly keep up with the many commissions for new houses from his well-heeled friends.

One of these was "The Grove" for William Kenrick, which was constructed in 1877 on the foundations of Thomas Attwood's residence in Harborne Park. Two years later he built "Highbury", looking across the fields of King's Heath, for Joseph Chamberlain. In each of these, as well as his own new house – "Whetstone" in Somerset Road, Edgbaston, he gave full vent to his Ruskinian principles. But in these buildings of his mature style, he expressed more of the textural richness associated with Norman Shaw and the Aesthetic Movement.

John Bunce, who lived in another of Chamberlain's houses – "Longworth" in Priory Road, Edgbaston – praised "his mastery of picturesque form, his exquisite sense of colour, his remarkable power of conceiving and executing detailed ornament, his skilful use of new or revived materials, such, for example, as terracotta and decorative tiles, and his admirable skill in designing stained glass, metalwork in iron and brass, and domestic furniture," and that, to his mind, Chamberlain "recalled the great medieval artists to whom all arts of construction, design and ornament were familiar."[9]

For many of these domestic commissions, Chamberlain created exuberant interiors, for which he designed inlaid-panelled wall and ceiling decoration, built-in cupboards and book-cases, rich mantel-pieces, elaborate door-cases, doors and fittings, and so on. He frequently designed much of the furniture

too, combining it with fabrics, wall-papers and furnishings selected from Morris and Company. It was especially in the design of these elaborate interiors that Charles Handley-Read, (the first art historian to champion the qualities of Victorian design), considered that Chamberlain "formalised nature very successfully, avoiding the harsh and spiky eccentricities associated with Christopher Dresser."[10]

Birmingham Art Gallery contains a fine example of Chamberlain's furniture design in the Everitt Cabinet. This was made in 1880 as a wedding gift from the members of the RBSA to their Secretary, Alan Everitt, and contains twelve paintings by the leading members as well as inlaid panels and architectural details by Chamberlain.

Cecily, William Kenrick's eldest daughter, remembered the creation of her father's house, "the Architect was a great friend of my father's." Then she added perceptively, "there are two kinds of Architects, the ones with whom you quarrel violently and the ones who twist you round their finger – charming plausible creatures. J.H.Chamberlain was one of these – an ardent Gothic revivalist, a good draughtsman and designer."[11]

"The Grove" was demolished in 1963 but an impression of the interior may still be obtained from the panelled ante-room to the principal drawing-room which was rescued and re-erected in the Victoria and Albert Museum. This essay in domestic design reflects the artistic taste of the Dawson circle created from a synthesis of the best in Pre-Raphaelite craftsmanship and the highest principles of the civic gospel.

Chamberlain's treatment of the decoration for "The Grove", although plundered from so many sources, was nevertheless highly personal, and above all, faithful to the teaching of Ruskin. For, as Nicholas Taylor points out, in a note in Pevsner's WARWICKSHIRE, "in him, Ruskin's political as well as artistic ideas were expressed with more fidelity than in almost any other architect."

In common with most of his contemporaries, Chamberlain happily drew from a bewildering profusion of sources. Pre-Raphaelitism, the Aesthetic Movement, the Arts-and-Crafts Movement, Venice, Florence, the Far East, the Middle East, Medieval England, the garden and the hedgerow, all were plundered, as Chamberlain expressed his visual ideas through symbol-laden pattern and representational, didactic decoration. It is even possible to discover precursors of the sinuous lines of Art Nouveau and the abstraction of Art Deco.

Cecily continues her description of the house "the walls [of the Entrance Hall] were divided into a kind of trellis and each square had a different

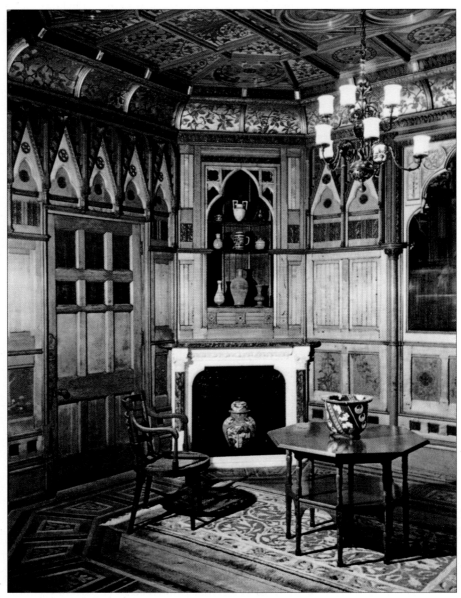

'The Grove' Harborne Park Road, Harborne. Ante-room to the Drawing Room designed by John Henry Chamberlain in 1877 for William Kenrick. The house was demolished in 1963, but the Ante-room was re-erected in the Victoria and Albert Museum.

design, sunflowers in one, great plane leaves in another, etc., and to hold it all together a little border of strawberry leaves in reds and golds....there was a high wainscot of light oak....the walls of the living rooms were all covered with pictures and still more pictures arrived and pushed the earlier ones upstairs. All the furniture was new....the Dining Room stained walnut with painted panels, discreet autumnal colouring. An overmantel of the same, framing a fine Linnell. A huge walnut table which seated dinner parties of twenty-four or more; Morris tiles in the fireplace. The Drawing Room had a recessed fireplace with Morris tiles, a carved mahogany overmantel framing a pleasant grey sea-piece of Henry Moore....the furniture had become straight and rather spindly with too much bevelled glass everywhere....the arm-chairs and settees comfortable....another sign of the Morris influence [was] a plaster ceiling and frieze. There were Morris papers in the bedrooms too. In our day and night nurseries were yellow encaustic tiles with line designs by Walter Crane illustrating fairy tales....it was a wonderful house for children....from the Landing we looked down into the Hall and could take stock of visitors and sort out the ones to be avoided."

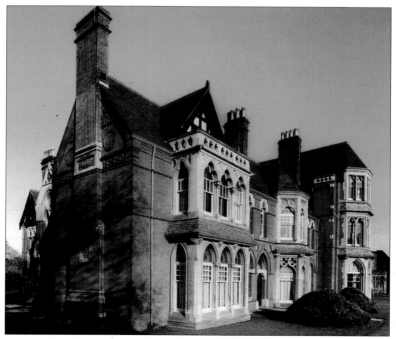

'Highbury', Yew Tree Road, Moseley. Designed by John Henry Chamberlain in 1879 for Joseph Chamberlain.

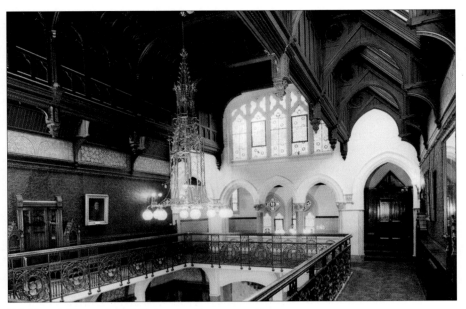

'Highbury'. The central Hall showing the upper gallery.

The visitors she recalled included John Bright – "with his leonine head and silver mane"; William Blake Richmond – "a most amusing talker"; William Morris – "with his blue shirt and his snuff which he spilt liberally over it, and his super-abundant energy – he could never be still a moment. He was fun"; Burne-Jones – "whom Papa liked best of all. They became real friends"; and William Holman Hunt – "who talked in pontifical style about the Pre-Raphaelite Brotherhood....one of the original brethren, and he let us know it!"

Although "The Grove" has vanished, "Highbury" has recently been sympathetically restored by the City Art Gallery and presents an even grander example of John Henry Chamberlain's architectural taste. For thirty years "Highbury" was one of the hubs of British political life as its processional plan of Entrance Hall, Great Hall, Dining Room, Drawing Room hung with Pre-Raphaelite pictures, the now-vanished Orchid Houses, and formal gardens, created the perfect setting for the reception and manipulation of important political visitors by Joseph Chamberlain and, after 1888, his young American bride, whose portrait was commissioned from Millais. In contrast, the masculine intimacy of Chamberlain's famous book-lined library (designed by J.H.Chamberlain for Joseph's previous home, "Southbourne"), still thrills with echoes of the notorious smoke-filled

conversations of the Chamberlain inner circle, to which John Henry Chamberlain had been a frequent contributor.

Not everyone admired his work. The local satirical magazine THE DART was fiercely opposed to the Liberal Party and constantly poked fun at Chamberlain's taste, whether expressed in his designing or in his lecturing. It wickedly caricatured Chamberlain as "Ye Apostlethwaite of Art", drooping in PATIENCE-like aesthetic dress with a sunflower in his buttonhole, a turreted building in each hand, and a tray of towering gothic buildings balanced precariously on his floppy hat.[12] After Chamberlain became a Justice of the Peace, and he was announced to give a lecture as J.H.Chamnberlain JP, THE DART mischievously asked whether his opinions "handed down from the Bench" would attract penalties if not complied with!

Chamberlain had been vigorously articulating his views on architecture, art and design for the past twenty years, and now he enthusiastically embraced a somewhat bizarre scheme of Ruskin's, which had overtones of the Community of the Nazarenes or the Brotherhood of the Pre-Raphaelites.

Ruskin's writing had been turning increasingly from art to a pre-occupation with the underlying evils of Victorian society and its capitalist economy. Ruskin did not like what he saw and was suggesting that his fellow-countrymen might be persuaded to turn away from industrialisation and competition and become a rural co-operative brotherhood which he proposed should be known as the Guild of Saint George.

In FORS CLAVIGERA, a fictitious correspondence to the working men of Great Britain, Ruskin had been formulating a grand concept of a fraternal society "voluntarily rendering obedience to great principles and not authority enforced by law." This new social order would reject the horrors of modern living and willingly return to the land, eager to pursue "the agricultural life", not in rude simplicity, but "combined with refinement."[13] He was an early advocate for ecology.

John Henry Chamberlain was one of the first to proffer his services to Ruskin. He was joined by his friends, Samuel Timmins and Quaker industrialist Alderman George Baker, who had just succeeded Joseph Chamberlain as Mayor of Birmingham.

Baker was about to move from his home on once semi-rural Birmingham Heath and had purchased an estate some eighteen miles to the west of Birmingham in the Wyre Forest where he had asked Chamberlain to design a turreted forest lodge. Baker offered a part of his "Beaucastle" estate – some twenty-seven acres – to Ruskin, for the use of the proposed brotherhood. Ruskin gratefully accepted and intimated that he would like to come and

inspect this piece of "Saint George's land" for himself. Accordingly, Ruskin's only visit to Birmingham came about.

On Friday, 13th July 1877, he travelled by train from Oxford and stayed the night at "Bellefield", Baker's home. The next day they visited Bewdley. Ruskin was delighted by the site. They returned to Birmingham where Ruskin captivated Baker's family.

Ruskin had insisted that his visit should be kept away from the limelight of publicity and was adamant "he would have no public dinner, so a compromise resulted in a few Birmingham men being asked to high tea." Besides Baker, Chamberlain and Timmins, they were the Editor of the Liberal BIRMINGHAM DAILY POST – John Thackray Bunce; Edwin Smith, Secretary of the Birmingham and Midland Institute; and the Alpine mountaineer C.E.Mathews – Town Councillor, lawyer, and Chairman of the School Board. These men all respected Ruskin as one of the great thinkers of their time.

Amongst such a gathering, the conversation over and after that high tea never ceased. The young Moseley Baker remembered, "the talk that resulted was such as I never heard before and shall never hear again in this life!"[14] Ruskin was overwhelmed. He was used to being listened to, and obeyed, in reverent silence. This company were used to the cut and thrust of ardent debate. Ruskin could hardly get a word in. After all, he had been thundering for some time against the de-humanisation that he perceived to be attributable to unrestrained urbanisation and rampant industrialisation. Yet these industrial and civic leaders – entrepreneurial yet deeply moral men – saw possibilities for a better quality of life within their dynamic town. They were arguing that the municipalisation of their town offered more likelihood of bringing Utopia to working men and women than any return to an imagined Arcadia. They knew that many of their own workers had been forced to leave the land to seek work in their factories and that industrialisation could bring benefits as well as evils. This group of earnest enthusiasts who talked so much were far from typical of their generation. They wanted to use their political, commercial and educational power to implant Ruskinian principles into their discharge of Dawson's civic gospel. At first Ruskin felt that he had been "taken prisoner by his natural enemies," but later he recorded they "had been very kind and have taught me much."

Within sight of "Bellefield", one of the largest of the new Board Schools was nearing completion – Dudley Road (later Summerfield) Schools. After tea, Chamberlain showed Ruskin round one of the most "Ruskinian" examples of his work. Baker's son was ecstatic. "Ruskin was up and down ladders like a schoolboy!"

When, in the October following Ruskin's visit the Guild of Saint George was formally constituted, among the first six Companions were Baker, Chamberlain and Timmins.

Far more slowly than Ruskin had anticipated, this number increased to thirty-two members. In 1879, the Companions were summoned to attend their first meeting. It was not staged in some Pre-Raphaelite castle, but at the dingy Queen's Hotel in Birmingham on the afternoon of Friday the 22nd February. Ruskin could not attend as he was still suffering from the indignity of the Whistler libel suit. George Baker took the chair.

In 1873, THE ART JOURNAL had stated that "the great capital of hardware takes the lead in provincial patronage of Art....its sales are always more than those of other provincial exhibitions. Artists are so numerous in Birmingham." Of the Autumn exhibition it noted "a gathering of pictures such as no provincial society of artists can approach (we do not except Liverpool or Manchester)."

In 1874, the Society had acquired an adjoining property and built an additional gallery which gave "beyond question the finest range of exhibition galleries in the provinces – indeed, excepting those of the Royal Academy, there are none in London to compare with them."[15] It was now possible to assemble over a thousand exhibits at each of the two annual exhibitions.

The Society's standing was further enhanced in 1879, when on becoming President of the Royal Academy, Sir Frederick Leighton also accepted the Presidency of the Royal Birmingham Society of Artists. Later in the same year John Henry Chamberlain was elected to follow Peter Hollins as the Vice-President. Leighton acknowledged Chamberlain as "a particularly amiable and agreeable man....[who was] devoted and enlightened a friend to art."[16]

Chamberlain had been a member of the Society since 1861. In 1870, he had become the first honorary Professor of Architecture, and as Vice-President, he was to take the Society into the most prestigious period of its existence.

Painting was flourishing in Birmingham as it had never done before. The Pre-Raphaelite influence waned during the 1870's. A younger generation of Birmingham artists left the School of Art to study in Antwerp. Edwin Harris and John Finnemore returned to Birmingham, but Fred Davis, Claude Pratt, William Breakespeare and W.J. Wainwright went on to Paris, where they haunted the museums and exhibitions, worked in the ateliers of Bougereau or Fleury, or made extended excursions to Brittany, to Venice or the Middle East. On their return to England, most of them wished to work in the up-to-date

plein-air fashion, so they followed Walter Langley, who had been joined by Edwin Harris, to paint in and around, the Cornish fishing village of Newlyn.

The more flamboyant Stanhope Forbes, is normally credited with the founding and leadership of the "Newlyn School", but Langley certainly got there first and the Birmingham men made up the largest number of the early visiting artists.

The Royal Birmingham Society of Artists showed its continuing confidence in its tolerance of these new ideas and new styles. Just as it had welcomed the Pre-Raphaelite paintings in the 1850's, in the 1880's under Chamberlain's leadership, it accepted the work of these younger artists. The penetrating draughtsmanship and moral tone of the Newlyn social realism gave a new edge to the naturalism of the established members, whilst the lighter palette reflected an awareness of new ideas coming from Paris.

'"Time moveth not, our being 'tis that moves"' 1883, by Walter Langley 1852-1922.

These Newlyn artists struggled to capture the spacious quality of the Cornish sea and sky, but unlike their French colleagues across the Channel in Brittany, they were unable to observe the local fisherfolk in the dispassionate, painterly manner of Bastien-Lepage. However much they admired the Frenchman's brighter palette and practised his "flat-brush" technique, they could not bring themselves to react merely to the colour and the warmth of the sun.

"Impressions" were not enough.

The English artists wanted to set down on canvas a record of the harsh existence endured by the Cornish fishermen and express their solidarity with the unceasing struggle of the women of Newlyn, as they suffered hardship and bereavement as a consequence of their uncompromising way of life. Were they haunted by their Birmingham Nonconformist conscience?

This concern with a significant subject differentiates the paintings of the English Newlyn School from the purely painterly pre-occupations of the French artists of Concarneau and Pont-Aven.

Could this concern be an unrecognised by-product of the civic gospel?

References

1. TIMMINS, S. *The History of Warwickshire* Birmingham 1889 p.207
2. ARMSTRONG, R.A. *William Henry Crosskey: his Life and Work* Birmingham 1985 p.249
3. FRASER, D. *Power and Authority in the Victorian City* Oxford 1979 p.173
4. BOYD, C.W. *Speeches of Joseph Chamberlain* Vol.I. p.41 1914
5. CHAMBERLAIN, J.H. *Inaugural Lecture* 21st October 1858, Queen's College Birmingham
6. *Pall Mall Gazette* 1894
7. *Birmingham Daily Post* 27th October 1883.
8. *Birmingham Daily Post* 17th September 1887
9. *Birmingham Daily Post* 23rd October 1883
10. COOPER, J. *Victorian and Edwardian Furniture and Interiors* 1987 p.94
11. DEBENHAM, C. *Recollections* Unpublished MS. c.1910
12. *The Dart* Christmas Supplement. December 1882. Birmingham
13. COOKE, E.T. and WEDDERBURN, A. Ed. *The Works of John Ruskin* Vols.XXIX, XXX. 1912
14. SCOTT, E.H. *Ruskin's Guild of Saint George* 1931 p.22
15. *The Art Journal* 1880
16. Letter from Sir Frederick Leighton PRA to Jonathan Pratt, Honorary Secretary of the RBSA. *Birmingham Daily Post* 1st November 1883

CHAPTER 4

WILLIAM MORRIS AND EDWARD BURNE-JONES IN BIRMINGHAM

In 1874, John Henry Chamberlain had been invited to serve on the committee of yet another of the cultural institutions of Birmingham. This was the Birmingham Society of Arts and inevitably he soon found himself Chairman. He set about the reform of this institution with the zeal he had already shown in tackling both the Midland Institute and the Society of Artists.

In a short time he obtained substantial sponsorship, appointed a new Headmaster, and changed the occupation of the men who filled the annual post of honorary President. He was able to persuade some of his wealthy friends to finance major changes in the School of Art. This enabled him to invite Edward R. Taylor, Head of the Lincoln School of Art, to take over at Birmingham. Then he persuaded his Committee to stop inviting local aristocrats to serve as President.

In 1877, his close friend Joseph Chamberlain MP, had filled this office, but from 1878, the Presidency was to be held by a succession of distinguished practising artists. The first was William Morris.

There can be no doubt that Chamberlain's invitation to Morris was to mark a significant shift in emphasis in the philosophy of the School of Art and have some far-reaching effects. It resulted in nearly twenty years of a unique relationship between Morris and the Birmingham School.

Morris frequently visited the School of Art, he sometimes served as a formal Examiner, he delivered several memorable lectures, and he commissioned work from students for the Kelmscott Press.

On his first official visit on 19th February 1879, after distributing the prizes in the Town Hall, Morris gave his large audience a characteristic address which concluded with a spirited appeal to the young students to take up crafts and to use their hands to fashion objects, rather than hanker towards fine art.

"If these hours be dark....do not let us sit heedless like fools and fine gentlemen, thinking the common toil not good enough for us, but rather let us work like good fellows trying by some dim candlelight to set our workshops ready against tomorrow's daylight, that tomorrow, when the

civilised world, no longer greedy, strifeful and destructive, shall have a new art, a glorious art, made by the people, and for the people, as a happiness to the maker and the user."[1]

From the tone of this speech, it can be seen that Morris was already seeing that art must change if it was ever to reach a wider public. Here he was urging art students to abandon easel painting and take up handcrafts, and he was looking towards the place of a new art in a new social order. In many towns in England this speech, at this time, would have been too radical, but the leading public figures in Birmingham welcomed his message. The Mayor, Jesse Collings, in thanking Morris, strongly supported his address, calling it "a vindication of the democratic and popular character of art."

Morris was back in Birmingham in November to address the first public meeting of the newly-formed Society for the Protection of Ancient Buildings. The meeting was to petition the Italian government to prevent the insensitive restoration of Saint Mark's, Venice. He was supported on the platform by the new Mayor – Richard Chamberlain (Joseph's brother), John Henry Chamberlain, William Kenrick, George Baker, and Samuel Timmins.

Chamberlain persuaded Morris to serve as President of the School for a second year, and it was in his address at the following prize-giving, in February 1880, that Morris first pronounced his now famous maxim on design, "Have nothing in your houses that you do not know to be useful, or believe to be beautiful."[3]

Whilst Morris was in Birmingham he stayed at "The Grove" as a guest of William Kenrick, and took breakfast at John Henry Chamberlain's new Edgbaston house – "Whetstone". Kenrick and Chamberlain took the opportunity to explain their hopes for art education in Birmingham, through their School and Art Gallery.

When Morris returned to London he went straight to "report himself and the impressions of his visit"[4] to Edward and Georgie Burne-Jones who had returned with Janey Morris from Rottingdean. The result of their conversation was a letter from Burne-Jones to John Henry Chamberlain. "Whilst talking with Mr Morris both before and since his visit to Birmingham, we have been much struck with the need there is in that important town for a Public Museum of Art. It is not too much to say that without one a School of Art is impossible."[5]

He continued, "An Art Museum is as essential for a student of art as a library is to the student of letters," He then outlined his ideas for such a museum. "In the basement should be placed casts of sculpture of the finest Greek and Florentine work....objects that would open the eyes and the hearts

of the students more than hundreds of lectures or lessons on art. In the upper rooms....a permanent collection of pictures, drawings and engravings, and a select library of books bearing on art." He then suggests that the pictures should not be of contemporary work which has not yet "been submitted to the verdict of time, but of the best copies procurable of the recognised masterpieces of the world." He enlarges on this proposal – "it would be a great thing if you could found a School of Copying in Birmingham; the result would be unique, and many and many a young man now doing poor work of his own....would then be able to support himself by making faithful copies of the best pictures whilst carrying on his own studies privately and gaining the best instruction by the very act of copying great art." He reasoned that "in course of time I know that even the silent presence of great works in your town will produce an impression on those who see them, and the next generation will, without knowing how or why, find it easier to learn than this one does whose surroundings are so unlovely."

Despite his interest in such a project for Birmingham, he resisted Morris's attempts to persuade him to accept Chamberlain's invitation to serve as the next honorary President of the Birmingham School of Art. Having failed to persuade Burne-Jones, Chamberlain took up Morris's alternative suggestion and invited the architect George Edmund Street.

Street, who had just completed the new Law Courts in London, accepted for 1880. Chamberlain continued this policy of attracting eminent artists. His friend, the painter Hubert Herkomer served in 1881, the architect Alfred Waterhouse in 1882, and William Blake Richmond began a long and fruitful association with the School from 1883. Holman Hunt came in 1893. He gave a very long, and extremely dull address!

The involvement of these artists, and their supportive speeches, paid dividends for the School. Kenrick later recorded that their presence had contributed to "arouse the interest and arrest the attention of the town, and notably some of its leading citizens, so as to make the subsequent proposals for the transfer of the School to the Town Council possible and acceptable."[6] And, of course, the influence of the Pre-Raphaelites was re-introduced to Birmingham.

Burne-Jones' letter reminds us that Birmingham was not alone in wishing to possess an Art Gallery. As Corporations became municipalised many towns competed to demonstrate their concern for culture by accepting the administration of museums and art galleries, after persuading wealthy philanthropists to fund both buildings and contents.

Nottingham Corporation had adapted the eighteenth century castle to

form an art gallery in 1878; Derby erected a gallery in 1881; Manchester Corporation turned the Royal Institution into the municipal art gallery in 1883; Cardiff built a Corporation art gallery in the same year; Liverpool created the Walker Art Gallery in 1884; Wolverhampton opened its elegant gallery in 1884; Sheffield expanded its 1875 museum into the Mappin Gallery in 1887; and Leeds opened its Art Gallery in October 1888.

Following the success of Aitken's exhibition at Aston Hall, one room in the Free Library had served as an art gallery since 1867, but this was no longer felt to be worthy of Birmingham.

Aitken had died in 1876, so his campaigning voice was stilled. There were no public funds to pay for a new building, or to purchase exhibits, so J.T.Bunce had been appealing through his editorial columns for private sponsorship.

In July 1880, he received a letter from the wealthy engineer brothers, Richard and George Tangye, referring to "the great loss the town sustains in the absence of an adequate Art collection".[7] The Tangye brothers offered to give the town £10,000 with which to buy paintings and artefacts on condition that the town provided a suitable building to house them. The Corporation gratefully accepted the gift and came up with a pragmatic solution to fulfil this condition. An empty building site immediately behind the Council House had been earmarked for Assize Courts, but the Corporation was prepared to give this site to the newly-municipalised Gas Department for it's offices, if it would incorporate an art gallery in its scheme! The Gas Committee (composed largely of Dawson men), gladly agreed to provide a gallery (at a cost of £40,000), and Mayor Richard Chamberlain was able to lay the foundation stone in 1881, with the appropriate inscription – "By the gains of Industry we promote Art."

As the building progressed, the Corporation created an Art Gallery Purchase Committee to spend the Tangye gift. Following the model of the existing Public Picture Gallery Fund which had been set up in 1871, the new Committee was made up of Richard Tangye, Aldermen Richard Chamberlain and William Kenrick, industrialist-collectors Sir John Jaffray and A.J.Elkington, John Henry Chamberlain and, assuming Aitken's mantle, the new Headmaster of the School of Art, Edward Taylor. Taylor's inclusion confirms his untypical standing, other towns would not have considered an art teacher to be the equal of its civic leaders.

The Committee intended to purchase "objects of Industrial Art" – precious metals, jewellery, brassware, ironwork, glassware and arms, "to strengthen the faculty of those engaged in Birmingham industries." However, in 1883, it

made a decision which was to have far-reaching consequences in shaping the future art collection. The Purchase Committee bought two Pre-Raphaelite paintings. They were both by Rossetti. At last, the work of the third major Pre-Raphaelite Brother could be seen in Birmingham. "Our Lady of Pity" and "The Boat of Love" were obtained from the studio sale following the artist's death.

Meanwhile, Chamberlain and the School of Art Committee had tried to persuade the Council to incorporate the School somewhere in the new Art Gallery building but without success. The present School was overcrowded and needed urgent repairs. The students had been moved from the Midland Institute into temporary accommodation in the attics of the Council House.

In spite of these difficulties, a generation of students who were to distinguish themselves as artists and designers studied at the School during these years amongst them Arthur Gaskin, Charles Gere, Edward and Sidney Barnsley, and Joseph Southall.

Southall was then a budding architect apprenticed to Chamberlain. He visited Ruskin at "Brantwood" several times during the 1880's with his uncle, Alderman George Baker, who had become Master of the Guild of St.George following Ruskin's increasing instability. In 1885, Ruskin considered moving his St.George's Museum from Walkley, near Sheffield, and he invited Southall to design a new museum to be built on Baker's gift of land at Bewdley. Ruskin had already ordered a ship-load of marble from Greece and cedarwood from Lebanon. Only the best was good enough for him!

Southall was despatched to Florence to make studies for the building. On his return his studies and plans were presented to Ruskin. However, Ruskin had changed his mind and decided to keep the Museum in Sheffield. Southall was forgotten. He later recalled "my chance as an architect vanished and years of obscurity without a little bitterness of soul followed".[8]

Having failed to find a suitable home for the School of Art, Chamberlain continued his campaign to obtain sponsorship for a new building for the School. Eventually, the Tangye brothers were prepared to donate £10,000, Louisa Ryland was offering £10,000, and Cregoe Colmore was willing to give a site close to the Council House. Richard Tangye insisted that their sponsorship should carry two important conditions. They were, that the School must come under the control of the Corporation, and that the new building was to be designed by John Henry Chamberlain.

Together, philanthropy and art, in the form of the Tangye's money and John Henry Chamberlain's architecture, would provide a building of art for

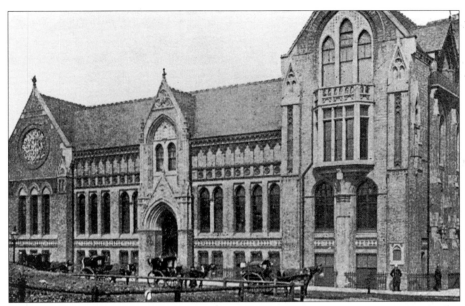

Birmingham Municipal School of Art, Margaret Street. Designed by John Henry Chamberlain in 1883. Photograph c.1900

the creation of art, and it would be administered by the Council for the general artistic good of the town. This was another example of the civic gospel in action.

The Birmingham School of Art became the first in the country to pass into municipal control, and for it Chamberlain was to create what many consider to be his finest design – the Municipal School of Art in Margaret Street.

Taylor was given leave of absence early in 1883 to go to France to visit various Art Schools to see for himself how they were equipped. He went on, to Venice to visit his former Lincoln student, William Logsdail, who was completing his 'St.Mark's Square, Venice' for the Academy Exhibition. This is why Taylor appears in the extreme top left corner of the crowd of English artists and tourists in this popular picture, now in the Birmingham Art Gallery.

Chamberlain completed his designs.

On 22nd October 1883, the Committee received the tenders for the School's construction. That same evening, after delivering a lecture on "Exotic Art", in which he castigated Classical architecture as foreign and exotic and unsuited to England before an appreciative audience in the lecture theatre he

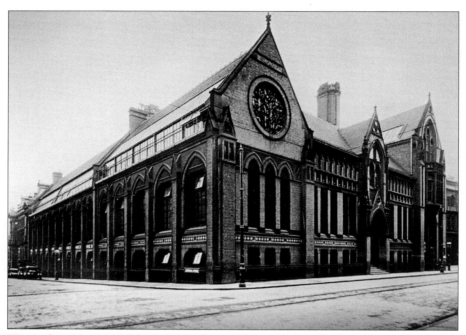

Birmingham Municipal School of Art, Margaret Street. Designed by John Henry Chamberlain in 1883. Photograph c.1930

had designed at the Midland Institute, Chamberlain collapsed and died of a heart attack. He was only fifty-two.

His death stunned the town and his funeral was one of the largest ever seen in Birmingham. It literally brought the town to a halt and gives some measure of the extraordinary esteem in which he was held.

The pall bearers included Joseph Chamberlain, now President of the Board of Trade; William Kenrick; J.T.Bunce; Samuel Timmins; Dr Crosskey; his principal builder John Barnsley; and a long-standing friend, the Pre-Raphaelite landscape painter John Brett ARA. A long procession of representatives of the many organisations with which he was associated followed the coffin to Key Hill Cemetery.

However, his partner William Martin supervised the building of the new School of Art. As the scaffolding came down, Samuel Timmins hailed the new School as "the most graceful and tasteful building in the town".[9]

Alderman William Kenrick MP, took over as Chairman of the Museum and School of Art Committee, and John Thackray Bunce chaired the School of Art Management Committee. As Editor of the BIRMINGHAM DAILY POST,

Birmingham Municipal School of Art. The ceramic roundel (12 feet in diameter) in the left gable of the Margaret Street facade, designed by John Henry Chamberlain, modelled by Joseph Bardfield, and made by King and Company of Stourbridge.

Bunce remained a staunch advocate for the arts, a tireless campaigner for education, and a mouthpiece for the Liberal cause. He was an admirer of Ruskin, although never going as far as to become a member of the Guild of Saint George. He had a notable collection of contemporary paintings in his Edgbaston home, which had been designed by Chamberlain, and he was the active honorary Professor of Literature for the RBSA for many years. He had been appointed a Justice of the Peace in 1880, at the same time as John Henry Chamberlain.

When the School entered its new building, Edward Taylor told his students, "for the first time in the history of our country a municipality has undertaken the direction of its Art School" and recalling those stirring speeches which had compared Birmingham to the Italian city-states of the Renaissance, he added, "it was under the fostering care of these municipalities that Art grew until it culminated in such men as Bellini, Titian, Giotto, Ghiberti, Raphael and Michelangelo," and he concluded, optimistically, "what future there is in store for our school we cannot say...."[10]

It was two years later that the London art critic, Alfred St.Johnston visited the School and saw the new buildings around Chamberlain Place, and made

his claim that "the Birmingham of today is perhaps the most artistic town in England."

Following his untimely death, Chamberlain had been succeeded as Vice-President of the Royal Birmingham Society of Artists by another architect, Julius Alfred Chatwin. He had studied at the Academy of Arts at Temple Row before being articled to Charles Barry. One of his first buildings was Bingley Hall, which replaced the temporary huts used for industrial exhibitions. He designed several Birmingham banks on Classical style, and many Birmingham churches in Gothic style, but was less identified with civic buildings.

In 1885, Chatwin triumphed where Chamberlain and Morris had failed. He managed to persuade Burne-Jones to serve as honorary President. Burne-Jones had finally agreed on condition that he would not be expected to give speeches or lectures. But, he wrote to Chatwin, "if it were thought desirable that I should visit the School, or meet the artists or pupils in some quiet way, without pomp or circumstance, it would be a delight for me,"[11] and to his friend Kenrick, he wrote, "all the time I am in the town I should like to work hard at the Schools – to see the students, separately if it is possible and give time to each of them....look at their designs and discourse with them about the ancients, and then return to Harborne to unbend and be convivial and cheerful and boisterous."[12]

He stayed for three days with Kenrick at "The Grove".

The visit had several consequences.

First, Burne-Jones spent a whole day at Margaret Street with the advanced students, talking privately with them and discussing their work. This visit was to have a lasting influence on the style of many of the staff and students. He was pleased with the work he saw and the students all fell under his spell, for Burne-Jones was at the height of his powers as a painter and designer for stained glass and tapestries.

The second consequence of his brief stay in his "beloved Birmingham" arose out of a visit made to inspect alterations being made to St. Philip's Church. Julius Chatwin was in the process of extending Thomas Archer's Baroque design to provide a chancel to hold a choir. Chatwin handled this addition with great sensitivity. He had re-sited its altar window, an "Ascension" designed a few years earlier by Burne-Jones, with the consequence that in the new chancel the artist now found his original design flanked by two large blank windows. Burne-Jones recalled that "I was so struck with admiration at one of my works in St. Philip's Church (may I mention parenthetically that in that very Church at the tender age of a few

weeks I was enlisted amongst the rank and file of the Church Militant) struck, I repeat, with admiration at my own work (a naive confession which all artists will condone) I undertook in a moment of enthusiasm to fill the windows on either side with compositions which I hoped....to make worthy of my former achievement."[13]

This spontaneous reaction, which presumably Chatwin had contrived, resulted in very original designs for a "Nativity" and a "Crucifixion".

The resulting set of windows thrill with the riches of Morris's palette and draw the worshipper into the mysteries of Burne-Jones's swirling symbolism. Their success owes much to the wide spaces of the Classical window openings, uncluttered by dividing mullions. The compositions indicate Burne-Jones' debt to Michelangelo as much as to any medieval source.

In 1896, Burne-Jones was to design a "Last Judgement" for the large west window. When flooded by the afternoon sun its rich reds are complemented by a band of subtle olives and browns in the buildings which prophetically pre-figure the forms of analytical Cubism. These four great windows must vie with the 'Holy Grail' tapestries and the Kelmscott CHAUCER for the accolade of the greatest achievement of late Pre-Raphaelitism.

The third consequence of this nostalgic and memorable visit was that Kenrick, by chance, introduced Burne-Jones to the poetry of the extra-ordinary Birmingham polymath and designer, Dr. Sebastian Evans RBSA. This was to lead, as Georgie Burne-Jones recalled, to "acquaintance, companionship, friendship, and at last, warm affection....and in the two years after Morris left us, Sebastian came nearer to Edward mentally than any other living man."[14]

The fourth consequence of his visit was that Kenrick prevailed upon the Art Gallery Purchase Fund Committee to commission a picture from Burne-Jones for the Gallery. This really was municipal culture in action – civic patronage of contemporary art. It was to be an 'Adoration of the Kings'.

At first sight, this may seem a rather strange choice for Nonconformist Birmingham, but a clue as to its suitability is given by Burne-Jones himself in a letter to Ruskin at the time.

"Do you remember ages ago, in Milan I think it was, when in the impudence of youth I said I liked the subject of the Shepherds best, and you straightway blew me up, and said "No, Ned, they had everything to gain by coming, and it was a greater grace in the kings to leave their kingdoms and come."[15]

Perhaps Ruskin was right. The humbling of wise men and the levelling of

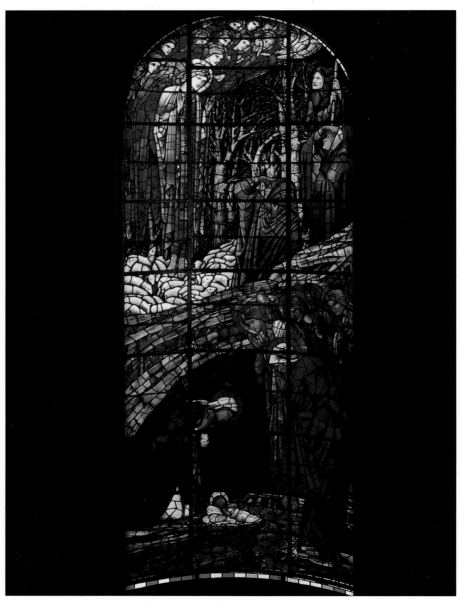

The Cathedral Church of Saint Philip, Birmingham.
Stained glass windows in the Chancel designed by Edward Burne-Jones 1833-1898 and made
by William Morris 1834-1896.
'The Nativity' 1885.

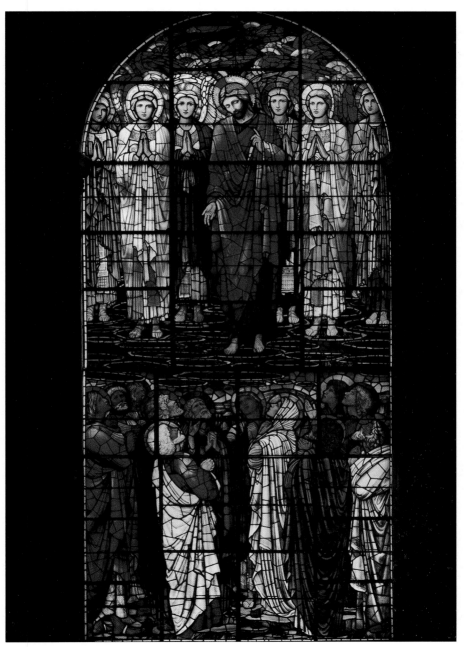

'The Ascension' 1878.

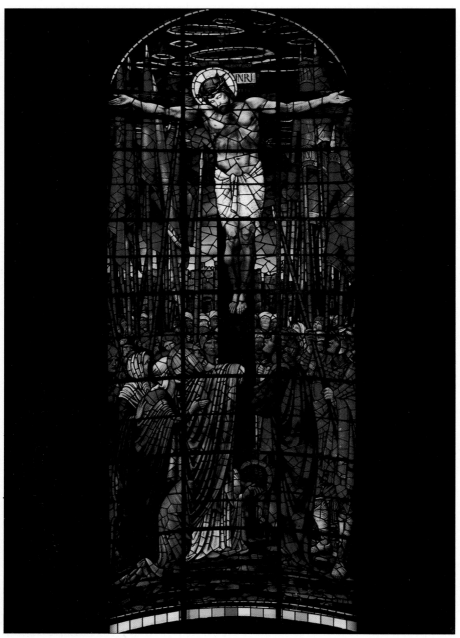

'The Crucifixion' 1885.

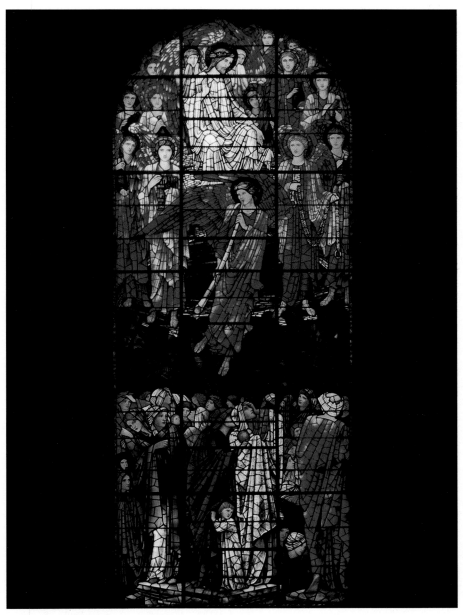

The Cathedral Church of Saint Philip, Birmingham.
Stained glass window designed by Edward Burne-Jones 1833-1898 and made by Morris and
Company. 'The Last Judgement' 1898.

kings was a more appropriate subject for radical Birmingham than the gawkish assembling of proletarian shepherds in the presence of the Holy Child.

Now called 'The Star of Bethlehem', this extremely large watercolour with life-size figures in glowing costumes, was begun in 1888 and developed during the period that Burne-Jones was carrying out the 'Briar Rose' paintings now at Buscot Park.

"It will be a blaze of colour and look like a carol" declared Burne-Jones as he clambered "up my steps and down, and from right to left. I have journeyed as many miles already as ever the kings travelled."[16] Morris loved the design and wove a version of it into a rich tapestry which hangs in the Chapel of their former College in Oxford.

In 1886, the British Association met in Birmingham again and a large Industrial Exhibition was staged in Bingley Hall. It far exceeded the exhibitions held in 1849 and 1865 in scope, quality, and impact. For the HANDBOOK prepared for the delegates, Edward Taylor wrote an article on "Painting in Birmingham".[17] He set out very clearly the current perception of the link between art and design. "The history of art proves that, when the nobler walks of painting and sculpture reach a high standard of execution,

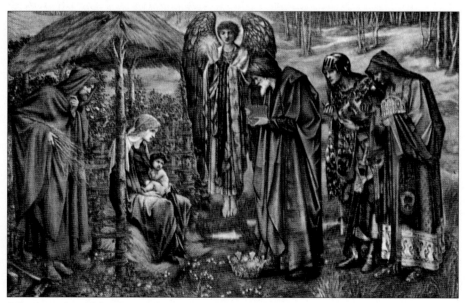

'The Star of Bethlehem' 1889. by Edward Burne-Jones 1833-1898. Commissioned by the City of Birmingham.

decorative character, and poetic insight, Art, as applied to Manufactures, makes corresponding progress", thus justifying the loan collection of contemporary pictures on exhibition in the Art Gallery.

Taylor believed that contemporary English painting was an outstanding example of such a process of art-led advance, as he continued, "decorative and poetic art in painting as seen in the works of Leighton, Watts, Burne-Jones, Rossetti, Mason, Richmond, Albert Moore, Walter Crane and others is of special interest to a manufacturing town like Birmingham."

He went on, "Birmingham has produced three great Masters – David Cox, "the first to carry out that direct study from nature which has become the characteristic of the English School"; George Hemming Mason, "who opened up still deeper sympathies for us"; and Edward Burne-Jones, "the greatest of the three."

John Hardman Powell, Hardman's nephew and Pugin's son-in-law, had succeeded Pugin as chief designer for Hardman's. In a lecture to the students at the Municipal School of Art in 1888, he said, "about a quarter of a century ago, seven young artists revolutionised Art in England. They were called Pre-Raphaelite, because they went back to the medieval habit of thought, tone of colouring, and minute study of detail, aided by the camera....Such a revival was welcomed gladly after the unsympathetic Classicism that had so long held possession of artists' minds." He then invited the students to "contrast the chance of the Art student in Birmingham now, where every important work of the time comes to be seen, to what it was thirty years ago. This age is the Paradise of Artists."[18]

Was it? It certainly was a decade of outstanding works of art. English painting was held in high esteem across Europe.

In 1889, when Paris first reacted with horror as M.Eiffel's steel tower soared to dizzy heights above their city, Burne-Jones's 'King Cophetua and the Begger Maid' was acclaimed at the Exposition Universelle and the French Government admitted the artist to the Legion of Honour.

In Birmingham, the Royal Society of Artists showed his 'Danae' and 'Sponsa de Libano' alongside Leighton's 'Bath of Psyche', Watts's 'Love and Life', Millais' portrait of the new Mrs Joseph Chamberlain, and Bougereau's 'First Sorrow'. THE MAGAZINE OF ART thought the 1889 Birmingham Exhibition "the best ever".

It is not difficult to substantiate Hardman Powell's boast. The Birmingham art student of the 1890's did not have to go to London. He could examine most of the leading examples of fashionable contemporary painting in Birmingham, either at the two annual exhibitions of the RBSA in New Street,

or in the spacious galleries of the new Municipal Art Gallery. He could visit the studios of many established painters to admire the latest works on "Viewing Sundays" before they were sent off to the Academy. He could call on aspiring artists in their studios along Broad Street to see new work for the Art Circle or the Easel Club. He did not even need to hanker for Paris. William Wainwright, the Birmingham artist who had studied in Antwerp and Paris, and now regularly examined the students' work, publicly claimed that the art education now offered in Birmingham was "equal to Paris".

So, in the minds of most Birmingham art students, and many artists, there was no doubt that they were living in an age which was a Paradise for painters, and that Birmingham was, without question, a second Eden. THE ART JOURNAL said "Anyone who has not visited Birmingham for some twenty years would be amazed today to see the wonderful change the architecture has undergone. The Londoner would find much to admire were he to take a stroll along the principal streets, or in the more fashionable suburbs. From being a dirty, inartistic, and smoke-grimed town – interested almost solely in the race for wealth – it has become, thanks to the public spirit shown by many of its foremost inhabitants, and by means of the development of [its] institutions, one of the most intellectual centres in the United Kingdom."[19]

Here is another commentator supporting the claim that Birmingham was "perhaps the most artistic town in England". He clearly attributes this transformation of Birmingham to the new civic leaders, and to the new cultural institutions.

In 1884, Whitworth Wallis had been appointed to direct the new art gallery. He was the younger son of George Wallis, the former Head of the Birmingham School of Art, who was now Keeper of the Art Collections at South Kensington. As his assistant Wallis took on Arthur Bensley Chamberlain, John Henry's son.

Wallis made extensive trips to Europe and the Middle East to purchase objects for the permanent collections, and from 1885 he organised a series of annual loan exhibitions of modern English painting, which leaned heavily towards the Pre-Raphaelites. These included the work of Watts and Burne-Jones in 1885, Langley and Henshaw in 1886, and David Cox in 1890. He also gave lectures at the Midland institute: on Holman Hunt in 1896; on Millais in 1897; on Burne-Jones in 1900; and on Rossetti in 1903.

These loan exhibitions proved to be very popular. In its first year of opening the Gallery was visited by over one million people and, in its first ten years, it received over eight million visitors, an average of two thousand

a day, considerably more than either the British Museum or the National Gallery could claim at that time.

THE ILLUSTRATED LONDON NEWS urged its readers to visit the new Gallery, declaring that Birmingham was a "much beslandered town, which is rapidly becoming one of the most beautiful in the kingdom".

In 1891, Wallis assembled one of the first exhibitions of Pre-Raphaelite painting. Culled from many private sources it included 'Beata Beatrix', 'Venus Verticordia', Sir Galahad', and 'Sir Tristram and Le Belle Yseult" by Rossetti; 'The Blind Girl', 'Mariana', 'The Proscribed Royalist', 'Ruskin', 'The Widow's Mite' by Millais; 'Strayed Sheep', 'The Scapegoat', 'The Shadow of Death', 'Isabella and the Pot of Basil', 'Two Gentlemen of Verona' by Holman Hunt; 'The Star of Bethlehem', 'Flamma Vestalis', 'The Wheel of Life' by Burne-Jones; 'The Last of England', 'Jesus washes Peter's Feet' by Madox Brown; 'The Death of Chatterton' by Wallis; 'April Love', and 'Ophelia' by Hughes; 'The Stonebreaker' by Brett; and work by Collinson, Windus, Solomon, Lewis, Severn, and Watts.

On the afternoon of October 2nd, a small invited audience of artists and civic leaders assembled to hear William Kenrick invite William Morris to open the exhibition. Among those present were Holman Hunt and Georgie Burne-Jones.

Morris made a short speech in which he praised the work for representing "nothing more or less than a branch of the great Gothic art which once pervaded all Europe", declaring loyally that "the man who added the absolutely necessary element of perfect ornamentation was Burne-Jones." To that ornamental quality, the Pre-Raphaelites gave "the Romantic quality", and thinking of their subject-matter, Morris claimed, "you will find throughout the whole of the history of the Arts, that when artists are....telling a story their works are....more fitted for the ornamenting of public buildings than when they are only thinking of producing works of ornament."[20]

At the close of this exhibition, William Kenrick purchased Millais' 'Blind Girl' and gave it to the Gallery.

The Birmingham industrialists and civic leaders had filled their Edgbaston villas with modern painting, preferably English, frequently Pre-Raphaelite, and now that they had their Municipal Art Gallery, they followed Kenrick's lead and either presented, or bequeathed, their pictures to their city. For example, Richard and George Tangye gave Albert Moore's 'Dreamers' in memory of John Henry Chamberlain; John Middlemore purchased and presented Holman Hunt's 'The Finding of the Saviour in the Temple', and Burne-Jones' 'Pygmalion' series; the Purchase Committee funded the

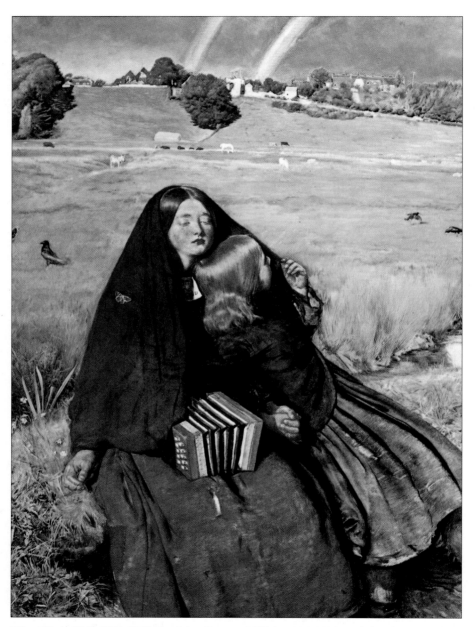

'The Blind Girl' 1854-1856, by John Everett Millais 1829-1896. Exhibited Birmingham Society of Artists 1856, exhibited in Pre-Raphaelite Exhibition at Birmingham Municipal Art Gallery 1891, purchased by William Kenrick and presented to the Gallery 1891.

acquisition of Holman Hunt's 'Two Gentlemen of Verona' and Madox Brown's 'The Last of England'. Wallis raised a special fund to purchase a large collection of Pre-Raphaelite drawings which had been accumulated by Charles Fairfax Murray.

The Birmingham art collections were therefore dominated by this late nineteenth century bourgeois taste which consisted almost entirely of contemporary English painting, especially by the Pre-Raphaelites, and work by the two Birmingham-born artists, David Cox and Edward Burne-Jones.

The significance of this support for the Pre-Raphaelite painters by the Birmingham Art Gallery, and by implication, by the city's civic leaders, was applauded by two contemporary observers. George Bernard Shaw, the dramatist and critic, who visited the exhibition after viewing the Burne-Jones windows in St.Philip's, noted, "on the whole Birmingham was more hopeful than the Italian cities: for the art it had to shew me was the work of living men,"[21] whilst the Impressionist painter Camille Pissarro, writing to his son from Eragny, drew a significant comparison between England and France. "It is a pity you were not able to go to Birmingham to see the assembled masters of Pre-Raphaelitism....the provinces in England are more sympathetic to innovators."[22]

Birmingham was now at the height of its municipal power as a provincial capital, revelling in its independence from central government. Its prestigious municipal art gallery and successful school of art were two symbols of that civic achievement.

In 1890, Walter Crane served as Examiner to the School of Art, and he applauded the efforts William Kenrick and Edward Taylor were making to reconstruct the curriculum towards design. A second phase of building had just been completed which doubled the size of the School with a block of well-lit, purpose-built, craft workshops. The Birmingham Municipal School of Art had become the first in the country to enable students to carry out their designs in metal, fabric and clay, instead of just drawing them.

So a longstanding Birmingham tradition of artist-designer, which had been given new life by the example and lectures of William Morris, led to the introduction of a Birmingham curriculum of art education by Edward Taylor to produce students who could draw well and work with their hands in a variety of crafts.

Aymer Vallance devoted an entire article to the Birmingham School in THE ART JOURNAL (1892). "The besetting sin of the art student is picture painting, of which sin the Birminghasm School is almost guiltless". Following the lead of Morris, he too exhorted all students "to abandon

picture painting for the time being, to devote themselves to the applied arts."[23]

Vallance was embracing both industrial design and the handicrafts of the emerging Arts-and-Crafts Movement. Nikolaus Pevsner, writing in 1937, found that the Birmingham curriculum had been "the first conceived under the influence of the Morris Movement",[24] and John Swift, in 1988, stated that, "during the years 1885-1920, the Birmingham School pioneered the 'new' method of learning design by using the actual materials; and created a whole 'School' of Arts and Crafts."[25] At no other School of Art did the Arts-and-Crafts Movement obtain such a foothold.

Although nearly ten years had passed since Burne-Jones's memorable visit to the School, the Pre-Raphaelite influence was still very powerful in Birmingham. Henry Payne was a young teacher there and he recalled, "In 1898, the atmosphere of the Birmingham School of Art aesthetically suggested William Morris and handicrafts. Gere, Gaskin, and I were on the staff and much influenced by Burne-Jones in subjects and schemes of design."[26]

Morris had paid many visits to the School of Art to give lectures or to serve as an Examiner from South Kensington. But in the 1892 National Competition, the black and white illustrations from Birmingham received particular acclaim, although the examiners did note that amongst the entries "there is a figure too directly taken from the work of a living artist."[27]

Despite this plagiarism from Burne-Jones, or, more likely, because of it, Morris was sufficiently impressed by the book illustrations emanating from the Birmingham School to ask several of the students to provide illustrations for books he was planning to printed at his newly-created Kelmscott Press. It was a signal honour and a remarkable tribute to the capabilities of the students. Morris did not approach any other Schools.

Charles Gere's drawing of Kelmscott Manor was used as the frontispiece for Morris's NEWS FROM NOWHERE, printed by the Press in 1892. Arthur Gaskin illustrated many articles for Morris and Edmund New's delicate drawings were used to illustrate several books about Morris. The young men used to cycle to meet Morris at Kelmscott, following routes he had suggested to visit ancient churches and decaying villages along the way. There were teas in the garden on arrival and, on one memorable occasion, Gere was reprimanded by Morris for cutting the bread too thinly!

In February 1894, Morris visited the Birmingham School of Art for the last time. On the afternoon of the 21st, he gave an illustrated lecture on "Woodcuts" during which he expressed his high opinion of the work of the

'Kelmscott Manor: the Garden Front' 1892, by Charles March Gere' 1869-1957. Frontispiece to NEWS FROM NOWHERE by William Morris, commissioned by Morris for the Kelmscott Press.

THIS IS THE PICTURE OF THE OLD HOUSE BY THE THAMES TO WHICH THE PEOPLE OF THIS STORY WENT HEREAFTER FOLLOWS THE BOOK IT SELF WHICH IS CALLED NEWS FROM NOWHERE OR AN EPOCH OF REST & IS WRITTEN BY WILLIAM MORRIS

students who had contributed illustrations and decorations to the Kelmscott Press. He returned to this topic to praise its source when, later that day, he distributed the annual prizes in Chamberlain's Lecture Theatre at the Birmingham and Midland Institute.

He ended his address with these words; "I, an old man now [he was sixty], have been much encouraged with what I have seen of the enthusiasm and aspirations towards the right road, of the Birmingham School of Art during the past few years."[28]

He had noted of the previous year's Arts and Crafts Society's Exhibition that "the only thing that is new....is the rise of the Birmingham School of book-decorators. These young men – Mr Gaskin, Mr Gere and Mr New – have given a start to the art of book-decorating."[29]

This opinion was drawn to the attention of a wider public by Walter Crane, who was himself one of the select band who created illustrations for the Kelmscott Press. In 1896, Crane published OF THE DECORATIVE ILLUSTRATION OF BOOKS OLD AND NEW and in the chapter on the recent development of decorative book illustration he emphasised the importance of the "Birmingham School" of illustrators, giving examples of work by Gaskin, Gere and New, as well as Inigo Thomas, Henry Payne, Bernard Sleigh, Fred Mason, Gertrude Bradley, Mary Newill and Celia Levetus.

Books like Crane's, and leading articles in THE ART JOURNAL, and THE MAGAZINE OF ART, carried the fame of these younger Birmingham artists across Europe and America.

An important contemporary French view of British Art was laid out in LE MUSEE D'ART: HISTOIRE GENERALE DE L'ART AU XIXe SIECLE published for the Libraire Larousse, Paris in 1906. Gabriel Mourey gave a very detailed summary of the visual arts in Britain throughout the century. In painting, he particularly praised the renaissance brought about by the influence of the Pre-Raphaelites, and described the years 1851 to 1882 as "this prolific period for English painting", and he listed among promising young painters, Arthur Gaskin, Joseph Southall, and Charles Gere.

When it came to the decorative arts, Mourey praised the importance of William Morris and quoted at length from his Birmingham address of 1880. He then joined Crane in highlighting the recent rise of the decorated book in England and singled out the work of Charles Gere, Arthur Gaskin, Georgie Gaskin, Edmund New, Inigo Thomas, Henry Payne, Mary Newill, Fred Mason, Fairfax Muckley and "the books illustrated by the other members of the School of Birmingham."

He praised the co-operation found in England between artist and craftsmen brought about by the art schools and handicrafts guilds where manual and industrial arts were taught together in the important centres of the United Kingdom such as Birmingham, and commended the patronage of the artist by leading industrialists there. He suggested a reason for the healthy state of the decorative arts to be that "England, unlike France, is not centralised," echoing Pissarro's comment. It was in the provincial capitals that Mourey had discovered the dynamo which was generating the "extraordinary artistic activity of contemporary England". He went so far as to declare that this activity had "completely transformed the taste of a nation" in under a quarter of a century. He concluded that "England is leading a renaissance which is transforming the homes of today's Europe, and those of tomorrow."

The newly-founded English art magazine, THE STUDIO, echoed this view of the role of the provincial capitals, especially singling out Birmingham, noting that, "we recognise at once that the Birmingham Art School must be considered by itself, for it is in no way a typical specimen of our provincial schools," and continued, "in metalwork, jewellery, enamels, book illustration and designs for manufactures generally, we are face to face with the original motive of the South Kensington scheme, which was founded....to raise the general level of design, and send out capable artisans and craftsmen to infuse once again into English goods the beauty they most certainly possessed in the past."[30] The writer found no dichotomy between art education for the industrial designer and art education for the Arts-and-Crafts designer, but that this common approach was the key to the success of the Birmingham School.

There is no doubt that the visits and personal involvement of Burne-Jones and William Morris played a large hand in keeping the Pre-Raphaelite flame

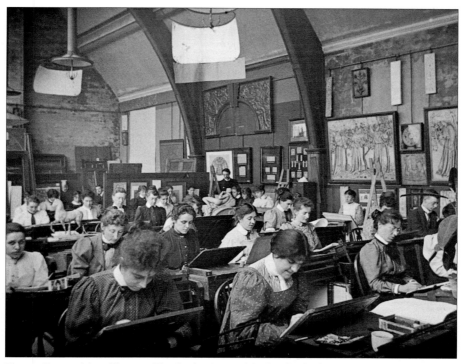

Figure Composition Class at Birmingham Municipal School of Art c.1900. The teacher is Henry Payne (standing at the back).

alight in Birmingham. Their presence and influence spawned a particular branch of late Pre-Raphaelite artists now categorised as "The Birmingham Group".

References

1. MORRIS, W. *The Art of the People* Birmingham 1879
2. *Birmingham Daily Post* 20th February 1879
3. MORRIS, W. *Hopes and Fears for Art* 1882
4. KELVIN, N. *The Collected Letters of William Morris* Vol.I Princeton 1984 Letter 612
5. BURNE-JONES, G. *Memorials of Edward Burne-Jones* Vol. II 1912 p.99
6. KENRICK, W. *Address* Leicester School of Art, 13th April 1892
7. DAVIES, S. *'By the Gains of Industry': Birmingham Museums and Art Gallery 1885-1985* Birmingham 1985 p.20
8. BREEZE, G. *Joseph Southall* Birmingham 1980 p.6
9. TIMMINS, S. *The History of Warwickshire* Birmingham 1889 p.273
10. TAYLOR, E.R. *The Art Student* No.1 October 1885 Birmingham
11. BURNE-JONES, G. *Memorials of Edward Burne-Jones* Vol.II 1912 p.155
12. *Unpublished Letter* 6th September 1885 Private Collection
13. BURNE-JONES, G. *Op.Cit* Vol.II p.172
14. BURNE-JONES, G. *Op.Cit* Vol.II p.158
15. BURNE-JONES, G. *Op.Cit* Vol.II p.176
16. BURNE-JONES, G. *Op.Cit* Vol.II p.176
17. TAYLOR, E.R. *Painting* in TIMMINS, S. *Handbook of Birmingham* Birmingham 1886 p.127
18. HARDMAN POWELL, J. *Stray Notes on Art* 1888 p.44
19. *The Art Journal* 1889
20. *Birmingham Daily Post* 3rd October 1891
21. ADAMS, E.B. *Bernard Shaw and the Aesthetes* Ohio 1971 p.16
22. REWALD, J. Ed. *Camille Pissarro: Letters to his son Lucien* 1943 Letter from Eragny, 5th November 1891
23. VALLANCE, A. *A Provincial School of Art* in *The Art Journal* 1892
24. PEVSNER, N. *An Enquiry into Industrial Art in England* Cambridge 1937
25. SWIFT, J. *Birmingham and its Art School: Changing View 1800-1921* in *Journal of Art and Design Education* Vol.7.No.1 p.25
26. PAYNE, E. *Henry A Payne RWS* Unpublished MS 1976
27. *Annual Report* Birmingham Municipal School of Art 1892
28. MORRIS, W. *Address* Birmingham Municipal School of Art 21st February 1894
29. *The Studio* 1894
30. *Ibid*

CHAPTER 5

BIRMINGHAM PRE-RAPHAELITES

By 1900, there were over four thousand students attending classes at the Central School of Art in Margaret Street, or evening classes held in Branch Schools throughout the city. The great majority of these students were still young male artisans, already in employment in the area, who attended evening classes to obtain instruction in drawing. For the few who were able to persevere to the dizzy heights of the Central School, there were opportunities to acquire practical experience in a wide variety of craft skills. The Birmingham Municipal School of Art was now equipped to satisfy the needs of industry for visually-literate "designer-workmen".

But under Taylor's leadership, there had been a steadily increasing number of fee-paying day students. They came to Margaret Street because there were no other openings for higher education in the city, especially for women, (and even more especially for Nonconformist women), and because the preaching of Ruskin and the example of Morris had made the study of art, or to be precise, the practice of handicrafts, into a fashionable and morally defensible occupation for the middle classes, especially women.

Of course there were critics of these middle class young women. One anonymous correspondent to THE DART complained that "some extremely clever lady students at our School of Art fritter their time away on painting before they have learnt to draw. And why is this? Simply because it is THE THING to patronise Art. Art is not studied. It is merely fashionable, and so fair Edgbastonia takes her neat little paint box and palette of an afternoon, spoils good canvases or daubs terracotta plaques and talks about "CULCHA"![1]

William Kenrick's own daughters, Cecily and Millicent, were among this group of privileged students. Cecily remembered that when she left Edgbaston High School, "we decided, Mama and I, that I must have something definite to do – so I started with 3 days a week at the School of Art and learnt to shade cubes and cylinders in charcoal in the then approved

style, and afterwards to paint still-life in watercolours and to stipple dreadful Art."[2] This certainly sounds like leisured 'Edgbastonia' with her "neat little paint box and palette" seeking "something definite to do"!

However, it could be argued that Cecily's art education was not entirely wasted. In 1888, during a sodden Scottish holiday, she met Ernest Debenham, a friend of her cousin Austen Chamberlain. Their subsequent marriage placed her, like her father before her, in the position to be more effective as a patron of the arts, for with Ernest, she was to be involved in commissioning the design and decoration of their extraordinary Kensington home. In a letter to her brother Byng, in 1904, she wrote, "Ernest is busy negotiating for a site on which to build a palace of white marble and De Morgan tiles – with gymnasiums and Turkish baths and vast libraries, and a dark hole of a bedroom for yours truly."[3]

"Debenham House" – the multi-coloured mansion in Addison Road designed by Halsey Ricardo with contributions from Aumonier, De Morgan, Gimson and Prior, became one of the great Arts-and-Crafts houses of London. And after the Great War, Cecily supported Ernest as he revived the rural economy of the Dorset hamlets of Bryantspuddle and Bladon, and housed his workers in clusters of idiosyncratic thatched model cottages designed by Macdonald Gill, around a War memorial carved by his brother, Eric, and a village hall lined with portraits by William Rothenstein.

Millicent caused her father much anxiety by falling in love with a fellow-student from the School of Art, who had a long name, but a very short purse. However, he accepted her choice, and as Claude Napier-Clavering was a silver designer, Kenrick set him up by taking over the Birmingham Guild. This had been established in 1895 as a self-supporting co-operative workshop with about twenty craftsmen, headed by Arthur Dixon.

Dixon was the eldest son of George Dixon (another Dawson man), and had been educated at Rugby and Oxford. It should be noticed that as the SON of one of the Birmingham elite he was not sent to the School of Art. Even so, he became an architect and an accomplished craftsman in silver and copper.

Dixon had designed the Guild's workshops in Great Charles Street, not far from the School of Art. With their warm red brick walls, gabled windows and hipped roofline, the workshops certainly did not resemble a factory. In similar style, he designed "Tennal Grange" in Harborne for the Napier-Claverings.

Dixon acted as voluntary Director until 1897, when Kenrick assumed virtual control by investing heavily in the Guild, creating a Board of

Management, with himself as Chairman, and installing his new son-in-law as Managing Director. It could be argued that by this take-over the Birmingham Guild was forced to betray its Morris-socialist ideals. It could equally be argued that Kenrick was setting an example to other limited companies (in the best Dawson tradition), to achieve economic viability through good design and sound craftsmanship. After all, did the Guild differ in this so very much from the firm of Morris and Company with its showrooms in Oxford Street? The Birmingham Guild was never intended to be an umbrella for a loosely-knit group of craftsmen.

There were young women who did not use the School of Art simply as a convenient finishing school. Following Morris and echoing Vallance, many of this group of young women did not seek to become easel painters, but sought instruction in a variety of craft skills, intended to prepare some of them, like Florence Camm, for active careers in one of Birmingham's many art-industries, and prepare others to be capable practitioners of hand-crafts, designers and makers of one-off objects.

The two daughters of Thackray Bunce were examples of this second group. Myra was a designer in many crafts especially in metalwork, and Kate became one of the leading painters to emerge from the Birmingham School at the turn of the century.

Jan Marsh, in WOMEN ARTISTS AND THE PRE-RAPHAELITE MOVEMENT(1989), sees Kate Bunce as a leading representative of what she identifies as the third, and final, phase of Pre-Raphaelitism. The sisters carried out many commissions for the decoration of local Anglican churches. Kate produced the paintings and Myra provided complementary settings or frames in beaten metal.

There were many women students at Margaret Street during these years who excelled especially in jewellery design, embroidery and book illustration. They included Georgie Cave France, Mary Newill, Celia Levetus, Ethel Cook, Margaret Gere, Gertrude Bradley, Kate Eadie, Constance Smedley, Evelyn Holden and Violet Holden. (Evelyn and Violet were considered to be the most talented but their sister Edith was to achieve phenomenal posthumous fame when her Nature notebook of 1906 was published in 1877 as THE COUNTRY DIARY OF AN EDWARDIAN LADY.)

It was in their classes that the full flowering of the Arts-and-Crafts Movement in Birmingham came about. This is well chronicled in a series of essays edited by Alan Crawford in 1984, as BY HAMMER AND HAND – THE ARTS AND CRAFTS MOVEMENT IN BIRMINGHAM.

Alongside the anonymous mass of students in the elementary classes,

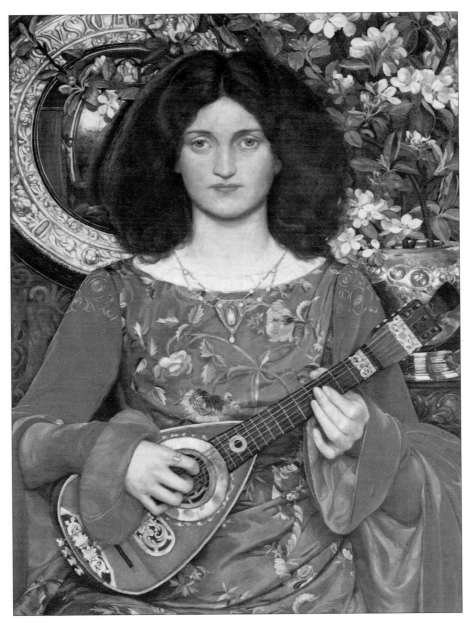

'Melody' 1895, by Kate Elizabeth Bunce 1856-1927.
Presented to Birmingham Art Gallery by Sir John Holder in 1897.

there was a notable body of artists and craftsmen and women with qualities far above the average art student.

These students continued to dominate the prize-lists of the National Competition, which still flourished much as it had done under Henry Cole. But the School was not allowing its students to be limited by the restrictions of South Kensington.

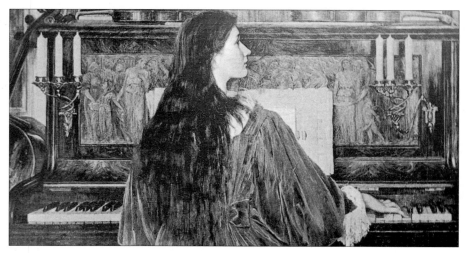

'A Reverie' 1897, by Edward Samuel Harper 1854-1941.
Illustrated in ROYAL ACADEMY PICTURES 1897

For example, in 1899, several students showed work at the Arts and Crafts Exhibition Society. Arthur and Georgie Gaskin showed jewellery, Charles Gere some church banners, Mary Newill her embroidery and stained glass, Joseph Southall exhibited a mirror with a gesso frame decorated by Gere, Edith Payne and Georgie Gaskin, and Arthur Gaskin showed a gesso panel.

A range of well-crafted objects was illustrated in THE STUDIO, but, as with Morris, the work which most impressed the magazine was the strong black-and-white book illustration. Twenty-two examples were reproduced, ranging from little vignettes to topographical studies, romantic idylls to children's book illustrations. The distinctive idiom shared by the Birmingham illustrators was described as the "English Style", and its origins were traced to the influence of Burne-Jones, the lecture of Walter Crane, and the recent Pre-Raphaelite exhibition in the town.

In the same year Liberty's launched "Cymric" silverware, followed by "Tudric" pewterware in 1902. Much of this was designed by staff or students

Illustration by Mary Jane Newill 1860-1947, from A BOOK OF PICTURED CAROLS 1893.

from the School of Art – such as Oliver Baker, the Gaskins and Bernard Cuznor, and made by the Birmingham firm of W.H.Haselor.

There appears to be little doubt that the most important factors contributing to Birmingham's emergence as a major centre for the expression of the Arts-and-Crafts Movement in the 1890's were one, the visits of Morris and Burne-Jones, and two, the role played by the School of Art.

No other town ever had an equivalent power-base. Their schools of art lacked the size, the flexibility of curriculum, and the independent local leadership enjoyed by Birmingham. Nor, as this book has signalled, had any other town enjoyed a similar strong Pre-Raphaelite tradition going back to Pugin.

For example, in Sheffield, the heavy steel industry did not need its labour force to have drawing skills. The School of Art catered for a mere 400 students and enjoyed only half-hearted municipal support, whilst the local Crafts Guild became a social club for workers in the silver and plating industries.

In Liverpool, the School of Art had 600 students, a Municipal Art Gallery, and a recently-established Applied Art Section connected with a School of Architecture in the new University. However, by the time this Section was combined with the School of Art, to form a Municipal School of Art in 1905, the impetus for the Arts-and-Crafts movement had largely evaporated.

Leicester had quite a large, but not yet municipalised, School of Art, and a small Corporation Art Gallery.

Even in Manchester, where there was a large Municipal School of Art with 1,300 students, a Municipal Art Gallery, and the Northern Art-Workers' Guild, (which had been inaugurated by Walter Crane in 1893), there was continuing friction between the members of the Guild and the School of Art, between the "practical" tradesmen and the "impractical" art teachers. More importantly, the Manchester School did not enjoy the support of an "artistic" middle-class.

During the 'nineties, as well as steady municipalisation of provincial art schools, there had been other changes in English art education. The National Art Training School at South Kensington had become the Royal College of Art, and Cole's Department of Science and Art was absorbed into a newly-created Board of Education. The new Board was very proud of Birmingham – its largest, and most successful art school. It sent examples of Birmingham's latest work to Budapest in 1899, and to the important Paris Exposition in 1900, where the International Jury awarded the Birmingham School a Gold Medal. A selection of work was also sent to the great St.Louis Centennial Exhibition in 1904, where it gained a Bronze Medal, and affected American art education.

Yet another display was sent by the Board to the Glasgow International Exhibition of 1901 "to show the results of the training of advanced students in the applied and decorative arts." However, there is a suspicion that the Birmingham work was really intended to counter what was seen as the subversive influence of the excesses of "Art Nouveau". Birmingham was trying to resist this influence but Glasgow was clearly encouraging it! Alongside the Birmingham exhibit, the Glasgow School showed a dazzling display of painting and decorative arts heralding the emergence of a distinctive Glasgow strain of the "New Art". The leading exponent of this Glasgow Style was the young Charles Rennie Mackintosh who was to design a new building for the Glasgow School of Art financed from the profits of the Exhibition. So, once-radical Birmingham was now being held up as the guardian of standards and Glasgow had become the innovator.

The new Royal College of Art remained, as its predecessor had been, the pinnacle of a national system, largely preoccupied with the training of art school teachers, rather than being a London college, so that, when greater London became a County in 1894, one of the first acts of the new County Council had been to set up a Technical Education Board, with, amongst other things, responsibility for art education. The Board sought advice from

Edward Taylor. He visited their existing art schools and classes and recommended that London should emulate the Birmingham system by creating a "central school" teaching a wide range of arts and crafts at advanced level, fed from over twenty "branch schools".

His advice was taken, and in 1896, the London County Council set up the Central School of Arts and Crafts under the leadership of the architect, William Lethaby, and the sculptor, George Frampton.

They soon established an enviable international reputation for crafts education which was far superior to anything offered by the Royal College of Art. Hermann Muthesius, reporting the findings of his fact-finding mission into art and design education to the Prussian government, thought it was "probably the best organised contemporary art school".[4]

Lethaby and Taylor established close co-operation between their two Schools, exchanging staff and students. W.R.Lethaby, already had links with Birmingham which were to be strengthened in the next few years. He had designed a large house near Sutton Park for C.E.Mathews in 1892, and between 1899 and 1903, two of his most influential buildings were under construction in the Midlands, one in central Birmingham, and one deep in the Herefordshire countryside. These were the office for the Eagle Insurance Company, almost opposite the Council House in Colmore Row, whose construction was supervised by the young Birmingham architect John Lancaster Ball, and his highly original church of All Saints, at Brockhampton.

Lethaby and Taylor exchanged the work of their students, and Taylor sent Henry Payne to learn the secrets of stained glass from Christopher Whall, and Ernest Treglown to study illuminating and lettering from Edward Johnston. In 1901, the annual students' Exhibition at Birmingham was examined by Lethaby, assisted by May Morris, William's younger daughter and now the leading designer for Morris and Company. She lectured to the Birmingham students on Medieval Embroidery in 1895 and was formally appointed a visiting Lecturer in Embroidery to the School of Art in 1899.

Lethaby was delighted with the quality and variety of craft techniques being practised at the School of Art. "The worksseem to me to show that much interest is being taken in the artistic crafts, and I believe great development will take place all over the country on the lines to some extent initiated in Birmingham". He singled out the metalwork teaching, the new class in lettering and book-binding, and praised the high standards achieved by the women students. He also was worried about the emergence of Art Nouveau as he went on to congratulate Birmingham for avoiding "overuse of the peacock as a motive" and the "absence of vulgar designs" in the

posters. He criticised the jewellery for "too many squirms", but was sufficiently impressed to declare: "such work done at Birmingham will react on London." May Morris thought the embroidery "promising", and Taylor concluded that it was "the best competition I can remember."[5]

Lethaby and May Morris acted as Examiners again in 1902. Lethaby was pleased with the stained glass workshop being created by Henry Payne, but reprimanded the architectural students for "picturesqueness", stating "No one thought of making an old church or cottage picturesque, more than they thought of it in designing a ship!"[6]

One of the craftsmen Lethaby appointed to teach at the Central School in London, was Robert Catterson-Smith, who had just completed three years of painstaking work with William Morris translating Burne-Jones's designs into black-and-white wood-blocks for the great Kelmscott CHAUCER. He was also an accomplished silversmith. When Kenrick and Taylor re-organised the Vittoria Street School of Silversmithing and Jewellery in 1901, Catterson-Smith was invited to become its Head. Two years later, on the retirement of Edward Taylor, it was Catterson-Smith who was appointed to succeed him as Head of the Birmingham Municipal School of Art.

Catterson-Smith was appointed because of his impeccable arts-and-crafts pedigree, and personal contacts with Morris and Burne-Jones. However, he was soon embroiled in the growing tensions between the Pre-Raphaelite principles of hand-crafts, with which to provide for the demands of the still-powerful, middle-class elite, and the commercial principles of the trade-centred demands of the industries of the city.

Neither Taylor nor Catterson-Smith saw the needs of local industry as their first priority. They both deferred to the views of Lethaby, as expressed in lectures he gave to the Municipal School of Art in 1901. In February, at the annual prizegiving, he declared that the Birmingham School was "hardly typical", and that in many respects "it must stand first in the kingdom". He reminded his young audience that to their hands was "entrusted the beauty-sense of the community", and that "good work done in this field is as noble a social service as effort in any other essential activity." A very Dawsonian concept. He urged them to look on handicrafts as the "most beneficial, most healthful and joyful of careers", and their pursuit was to lead to the "preservation of the natural beauty of our country, and the order of our civic life."[7]

He certainly did not appear to see Art dirtying her hands with Industry, as he concluded that the aim of art was to give "sweet, tidy towns, and smiling country under skies free from smoke....A new Heaven and a new Earth."

This sentiment, which clearly stands comparison with Morris's vision of England in NEWS FROM NOWHERE, whilst welcomed by Taylor and Catterson-Smith, was surely more applicable to the Guild of Saint George than to the majority of Birmingham factory floors.

In a second lecture given in October, Lethaby addressed the students on "Morris as Workmaster", quoting Ruskin, "What I mean by art is some creation of man which appeals to his emotions and his intellect by means of his senses", and argued that Morris was not a designer, "he was a work-master", he was "Morris the Maker."[8]

A few years earlier Edward Taylor had given up painting and taken up a craft as he had encouraged so many of his students to do. In 1898, with his son Howson, he began to experiment with a small kiln in the back garden of their home in Edgbaston. This had led to the establishment of a permanent art-pottery at Smethwick, which was named the Ruskin Pottery. Its rich colours, derived from leadless glazes, led to the souffle, lustre and flambe wares, which Howson Taylor made the distinctive hallmark of one of the great art-potteries of the Arts-and-Crafts movement

Of course it was inevitable in this stimulating atmosphere, with such a large student body, that many talented artists and craftsmen, and women, would emerge from the Birmingham School of Art. Maybe the extravagent hopes that the municipal revolution would lead to a second Renaissance and foster some more Raphaels or Michelangelos were over-ambitious, but talent there was in abundance.

Besides the generation of social-realist painters who had studied at the Birmingham School of Art under Taylor before it moved into its Margaret Street home, and then gone on to Antwerp, Paris, Venice and Newlyn, there was now a much larger second wave of Birmingham alumnae. They were never formally organised, but in the years preceding the First World War, some of these graduates from the School of Art exhibited their work together, and some of them collaborated closely in joint productions.

For example in 1907, ten former students exhibited a wide range of paintings and crafts at the Fine Art Society in Bond Street, London. The catalogue described Arthur Gaskin, Bernard Sleigh, Charles Gere, Edmund New, Joseph Southall, Kate Bunce, Maxwell Armfield, Norman Wilkinson, Sidney Meteyard and Violet Holden as "a group of Birmingham Painters." In 1911, Catterson-Smith referred to "a group of students who have since been designated the 'Birmingham School'".[9]

In the introduction to the Catalogue of the 1907 Exhibition, these Birmingham artists claimed to be "largely influenced by admiration of

Joseph Edward Southall 1961-1944

Edmund Hort New 1871-1931

Arthur Joseph Gaskin 1862-1928

Violet Mary Holden 1873-1939

Drawings by "some of the earlier members of the Birmingham Black-and-White School" in an Album presented to Edward R.Taylor on his retirement as Head of the Municipal School of Art in 1903.

Italian pre-Raphaelite Art as being, in their opinion, superior to the work of the later Schools both in vital and ornamental power and therefore fitted to be a starting point for further development" They explained that their work was "essentially architectural in character and aims not only at the imitation of Nature but also at the recovery of that connection between Architecture and Painting, the loss of which has been so disastrous to both Arts."[10]

In this, they were echoing a Ruskinian argument approved by John Henry Chamberlain and commonly reiterated by the Arts-and-Crafts Movement, but the quality which most of their work shared was one which marked out these artists as deriving from Birmingham, and shows one of the subtle ways in which the civic gospel interacted with art. Their work did not simply share the superficialities of a common style of technique or execution, but, more importantly, what it had in common was "a vital and ornamental power". This, they owed to Birmingham and derived from their radical and Nonconformist inheritance. It was vividly expressed in the selfless idealism of the individual artists. This quality is the Birmingham hall-mark of these artist-craftsmen and women.

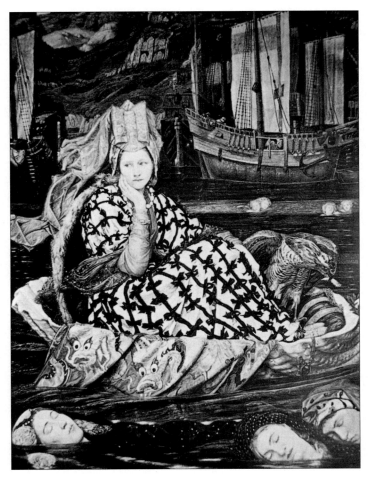

'The Enchanted Sea' 1900, by Henry Payne 1868-1940. Private Collection.

Just as the Birmingham members of the Newlyn School had shared a common concern with moralising subject matter, which reflected their Birmingham origins, so the Birmingham Group shared a "well-mannered" art expressed with great conviction and quiet strength.

They exhibited a variety of work, which included book illustration, engravings on copper, book-plates, drawings, woodcuts, jewellery, silver, portraits on vellum, watercolours and oils, as well as the egg tempera and buon fresco paintings which attracted most attention from the press.

Claude Napier-Clavering pointed out, in THE STUDIO, that although they had learned from Burne-Jones "at the School of Art where the influence of that great painter was naturally very strong", and that Morris and the Pre-

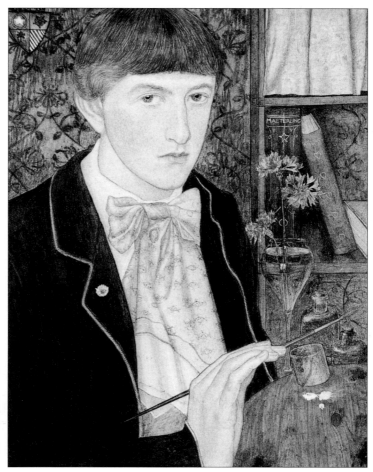

'Self-portrait'
1901,
by Maxwell
Ashby Armfield
1881-1972.
Birmingham Art
Gallery

Raphaelites had "much to do with the moulding of many of them", it was equally true that Southall and Gere had gone to Italy, or to the Italians in the National Gallery, to study. Catterson-Smith believed that their concern for the "medieval schools of North Italy" had enabled them to "keep free of the more nebulous modern spirit."[11]

In 1919, a special exhibition by "a Birmingham Group" was held in the RBSA galleries in New Street. The Catalogue for this exhibition carried an introduction by the Birmingham poet and playwright, John Drinkwater, who wrote that "a community can rarely have produced a body of artists so admirable in technique and so undistracted in their vision".

Sadly, their collective potential was never given the chance to be expressed in their home city. Their most comprehensive scheme was not carried out in Birmingham, but at Madresfield Court, near Malvern. In the light of this book, it is disappointing that this commission came, not from a Nonconformist, Liberal, middle-class industrialist, or from a powerful radical municipal corporation, but was to celebrate the union of two of the most wealthy, landed, aristocratic families in the land, those of Grosvenor and Beauchamp.

In 1902, Lettice Grosvenor, sister of the Duke of Westminster, had married William, the seventh Earl Beauchamp, and as a wedding present for her husband, she invited the Birmingham artists to convert a billiard room at their country seat, Madresfield Court, into a chapel. Charles Ashbee and his Guild were already carrying out a decorative scheme for the library, and it must have been Ashbee who recommended the Birmingham artists to Lady Beauchamp.

The overall scheme was planned by Henry Payne, who designed the wall-paintings and made the stained glass. The altar was designed by William Bidlake with panels in tempera by Charles Gere, who also designed the embroidered Frontal. Arthur and Georgie Gaskin made the silver crucifix and candlesticks, and the altar lamps were made by the Birmingham Guild to their design.

It remains an extraordinary experience to enter the chapel. It still retains that bitter-sweet quality of innocence which reduced the artist-hero of BRIDESHEAD REVISITED to a single "Golly!" Evelyn Waugh had not forgotten the impact of this chapel, encountered during house-parties at Madresfield whilst he was a student at Oxford. He used it when he re-sited the chapel at his fictitious Brideshead. The decoration and furnishings of the Madresfield Chapel must rank as one of the finest vindications of the combined ideals of Pre-Raphaelitism and the civic gospel.

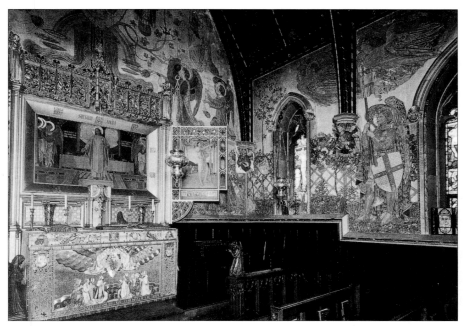

Beauchamp Chapel 1902-1923, Madresfield Court, Nr.Malvern. View of the Altar. Overall design, wall-painting and stained glass by Henry Payne 1868-1940; executed by Payne assisted by Henry Rushbury 1889-1968 and Richard Stubington 1885-1966, altar designed by William Bidlake 1862-1938; altar triptych painted by Charles Gere 1869-1957; embroidered altar frontal designed by Gere; silver crucifix and candlesticks designed and made by Arthur Joseph Gaskin 1862-1928 and Georgie Gaskin 1866-1934; altar lamps designed by the Gaskins and made by the Birmingham Guild.

Art continued to maintain a relatively high profile in Birmingham as the city grew between 1890 and 1914.

In terms of prestige: a Ruskin Society was formed. Besides holding meetings it published a quarterly journal SAINT GEORGE. In 1901, the Society took over the London Ruskin Union and set up a prestigious committee to deliberate on the form of a national memorial for Ruskin who had died the previous year. This was eventually placed, not in London, or in the Lake District, but in Birmingham, as the heart of the garden suburb being created by George Cadbury around his chocolate factory at Bournville. "Ruskin Hall" contained a library, an art gallery, a museum and a school of art.

In terms of architecture: there was more municipal building, including market halls, district libraries, fire stations, baths, and Board schools; there

was more public building, including hospitals, law courts, and the new university; and complementing this, there was a considerable amount of industrial, commercial and domestic building as the city continued to expand its boundaries. The influence of the Gothic revival declined as a new generation of Birmingham architects absorbed the Arts-and-Crafts idiom. They included J.L.Ball, Joseph Crouch, Arthur Dixon, W.H.Bidlake, Charles Bateman and H.T.Buckland.

In terms of art: the exhibitions of the Royal Birmingham Society of Artists' continued unabated; and the two municipal institutions – the School of Art and the Art Gallery – both more than doubled in size.

The two annual exhibitions of the Royal Birmingham Society of Artists continued to follow the well-tried formula of a combination of the members' latest work with paintings submitted by willing Academicians. These exhibitions remained representative assemblies of academic-realist English painting, apeing the Royal Academy, but the Academy itself was being seen increasingly as reactionary, as the older generation resisted the new work being created across Europe.

Sir Frederick Leighton Bt.PRA, Sir John Everett Millais Bt.RA, and Sir Lawrence Alma-Tadema,RA, were elected honorary members in 1885. Burne-Jones and Watts followed in 1887 and 1889. Senior RA's continued to serve as honorary Presidents, Julius Chatwin was succeeded as Vice-President by yet another architect, Jethro Cossins in 1902, and three years later, the Right Honourable William Kenrick,PC, was elected an honorary Vice-President.

Membership of the Royal Birmingham Society of Artists was still seen as a respected seal of approval for the aspiring Birmingham artist, and increasing numbers of applicants were duly elected associates and members. Nearly all had been educated at the School of Art, and it is a convincing measure of the quality of these new applicants that all those elected during these two decades were still intending to follow careers as professional painters and architects. But membership, whilst conferring some degree of professional status, could no longer be guaranteed to provide an adequate income from Birmingham patronage alone.

The 1895 Autumn Exhibition, "one of the best for a number of years", included some of the newer Academicians, and the work of some of the younger Birmingham artists showing the influence of Burne-Jones, including Joseph Southall, Arthur Gaskin, Norman Wilkinson and Maxwell Armfield. In 1897, it still honoured the Pre-Raphaelites by giving pride of place to Burne-Jones's 'Dream of Lancelot', and Holman Hunt's 'May Morning'.

The pictures, in their heavy gold frames, were still crowded together, as they had been for the past seventy years, three or four rows deep, with the fashionable favourites hung "on the line" in the place of honour in the Circular Gallery.

The outward semblance of a thriving senior art institution was there, but significantly, there had been a steady decline in visitors to the Society of Artists' exhibitions since the opening of the Municipal Art Gallery. The Gallery which the Society had done so much to bring about, was proving a more successful rival. Its great loan exhibitions received large numbers of visitors, some thirteen million in twenty years, and the Society of Artists found itself no longer at the centre of the cultural life of the city. Its two annual exhibitions lost their attraction. Viewing the latest Academy pictures was no longer felt to be essential, and buying and owning paintings was less fashionable. Wainwright noted, "two classes of frequenters of the galleries were in process of withdrawal – the speculative buyer and the artisan." Gallery-going was no longer almost the only recreational activity open to the working man and his family besides chapel-going. It was no longer enough that the working class should seek "improvement" through the contemplation of moralising pictures. There were now wider horizons – cheaper travel by bicycle, tram and railway, sea-side holidays, an explosion of spectator and participating sports, and other forms of popular entertainment such as the music hall and "moving pictures" at the new cinemas. Nor was it any longer felt to be the required duty of the privileged middle classes to be seen attending the Society of Artists' private view and patronising local artists.

As a final blow to the prestige of the Birmingham Artists, the lease on the Society's galleries in New Street expired, the building was pulled down, and the site re-developed with a small gallery on the first floor. It was reached by way of a panelled stairway from the street, each panel emblazoned with the names of their former illustrious honorary Presidents and all their previous members, as if pleading with the visitor not to forget the Society's glorious years.

But with the demolition of the circular gallery and the pillared portico across the pavement in New Street, the city lost one of its most distinctive landmarks, and the Royal Birmingham Society of Artists lost both its roots and its pre-eminent role as a major cultural institution.

However, the Birmingham artists still dreamed of making their city a rival of Venice or Florence. They were encouraged by the painter William Rothenstein who told them, in 1908, that "Birmingham stands easily first

among English cities in its art activity" and that "you have here in Birmingham one of the soundest and most vital training places for artists in Europe." He asked the civic leaders "is it so wild a dream to think of these students being encouraged to plan and execute decorations for your public buildings, to carve and paint the portraits of your noblest citizens, to design your sign-boards, and superintend everything which appertains to the beauty of your city?"[12]

This idea was not new. Edward Taylor had urged the greater use of narrative painting and sculpture on public buildings to illustrate examples of civic achievement, past and present, in an address to the third Congress of the National Association for the Advancement of Art and Its Application to Industry, held in Birmingham in 1890. Morris had made the same suggestion in his speech at the opening of the Pre-Raphaelite exhibition in 1891. Kenrick had actually paid for a scheme, initiated by Bunce, to decorate the Town Hall with pictures by selected students. The cartoons were exhibited at the Arts and Crafts Exhibition Society in 1894 and were praised by Walter Crane, who compared the designs favourably with Madox Brown's murals at Manchester. The final paintings, on canvas, were carried out and hung in the Town Hall, but the sighting and illumination were unsympathetic. They survived until 1927.

The current City Council proved less supportive. Although Whitworth Wallis and members of the old middle class were busy accumulating the finest collection of Pre-Raphaelite paintings and drawings in the world for their Art Gallery, they were less responsive to the new generation of "Birmingham Pre-Raphaelites". What might have been a blossoming of artistic talent to create a city of beauty was never given a chance. The municipal gospel was not given the opportunity to mature from its Pre-Raphaelite beginnings into a visual style which could have enlivened the streets and buildings of Birmingham.

We can only speculate what might have happened if the members of the Birmingham Group had been given their heads?

William Bidlake did make plans for a new civic heart. He proposed to turn Broad Street into a tree-lined boulevard with a grand square at each end. Around the Five Ways Square he would have sited the new University, and around the new Central Square beside the Town Hall, he planned a new Anglican cathedral, and a new gallery of modern art.

But the inter-connected roles of artist and designer which had provided a unique opportunity for the Birmingham artists in 1814, had given way by 1914, to the diverging roles of the fine artist working in his studio, and the

artist-craftsman in his workshop, both only too thankful not to be involved with industrial design. Inexorably, most of the members of the Birmingham Group drifted away from Birmingham, many to seek refuge in rural communities in the Cotswolds.

Of the original group only Southall remained. Of independent means, he was a staunch Quaker, an ardent pacifist, a member of the new Independent Labour Party, and had taken up painting following his disappointment over the designing of Saint George's Museum for Ruskin. In the best Birmingham tradition, he was a very fine draughtsman and he had become an expert on the techniques of tempera and fresco painting. No-one could have been better fitted to create public works of art to decorate Birmingham's civic buildings. But, even with his family connections, he was unable to persuade the city to fund public art. In the end, he did carry out some schemes, but he had to pay for them out of his own pocket.

The finest example still welcomes each visitor as they mount the stairs to the Art Gallery. This is his spirited mural entitled 'Corporation Street, Birmingham in March 1914'.

'Corporation Street Birmingham in March 1914' 1916, by Joseph Edward Southall 1861-1944. Fresco in Birmingham Art Gallery.

Did Southall realise he was capturing this moment at a turning point in European history? Set in front of one of the facades designed by John Henry Chamberlain, a horse-drawn wagon trundles past a fashionably dressed Mrs Arthur Gaskin, escorted by John Drinkwater and Whitworth Wallis. A drab flower-seller and Mrs Gaskin's well-dressed daughter contrast in the foreground. The painting was carried out in the exacting technique of buon fresco. William Rothenstein believed it to be "the most perfect fresco painted during the last three centuries."[13]

It is a dispassionate image, recording the activities, the people, and the fashion of the Birmingham of 1914 with the same objectivity aimed at some sixty years before by Ford Madox Brown in 'The Last of England'. In this objectivity, as in its precisely-observed detail, the picture owes a debt to Pre-Raphaelitism. Southall has taken an ordinary moment, and transformed it into a memorable image, of its time, as a record for all time, just as his world was about to be jolted into a new, and very different climate.

It is unquestionably, a "thoroughly good picture".

Perhaps it should serve as the final homage to Pre-Raphaelitism in Birmingham.

References

1. *The Dart* 3rd August 1883 Birmingham
2. DEBENHAM, C. *Recollections* Unpublished MS. c.1910
3. *Unpublished Letter* 15th December 1904 Private Collection
4. PEVSNER, N. *Academies of Art: Past and Present* 1940 quoting from GRAUS, R. *Die Krisis im Kunstgewerbe* p.265
5. *Annual Report* Birmingham Municipal School of Art 1901
6. CATTERSON SMITH, R. *Birmingham Municipal School of Art* in MUIRHEAD, J.H. *Birmingham Institutions* Birmingham 1911
7. LETHABY, W.R. *The Study and Practice of Artistic Crafts* 1901
8. LETHABY, W.R. *Morris as Work-Master* 1901
9. CATTERSON SMITH, R. *Op.Cit*
10. *Catalogue* for an exhibition of Works by a Group of Birmingham Painters and Craftsmen. November 1907 Fine Arts Society, Bond Street London
11. *The Studio* December 1907
12. ROTHENSTEIN, W. *Address* Birmingham Municipal School of Art February 1908
13. BREEZE, G. *Joseph Southall* Birmingham 1980 p.90

CHAPTER 6

PRE-RAPHAELITE BIRMINGHAM TODAY

The sympathetic reception of Pre-Raphaelite paintings throughout the nineteenth century by Birmingham artists and civic leaders has left a remarkable legacy. At the end of the twentieth century Birmingham finds herself in possession of an unrivalled collection of Pre-Raphaelite paintings and drawings. Most of these are in the Birmingham Museum and Art Gallery in Chamberlain Square.

Its nineteenth century galleries feature an outstanding collection of Pre-Raphaelite paintings, including Millais's 'Blind Girl'; Holman Hunt's 'Two Gentlemen of Verona' and 'The Finding of the Saviour in the Temple'; Rossetti's 'Beata Beatrix' and 'Proserpine'; Madox Brown's 'The Last of England' and a small version of 'Work'; and Arthur Hughes's 'The Long Engagement'. The collection is now re-hung to celebrate its recent successful tour across the United States.

The Gallery also possesses the largest collection in the world of Pre-Raphaelite drawings. Of course there are many paintings by Edward Burne-Jones, including 'The Star of Bethlehem', and the 'Pygmalion and the Image' series. There are paintings by David Cox and his friends in the early days of the Birmingham Society of Artists. There is an excellent selection of work showing the influence of the Pre-Raphaelites; paintings and craftsmanship of most of the Birmingham Group, and many of the Birmingham members of the Newlyn School. At the top of the main stairs is the fresco by Joseph Southall.

Besides the paintings, there are ceramics by William Morris, William de Morgan and Howson Taylor; stained glass by William Morris, Edward Burne-Jones, Hardman and Camm; textiles by Morris; and a variety of metalwares from Pugin and Hardman.

The Gallery also possesses a nearly-complete set of the 'Holy Grail' tapestries by Morris and Burne-Jones.

Of course, the building itself reflects another legacy of the ideals of Pre-Raphaelitism and the Civic Gospel.

Internally, the original galleries have been sensitively restored to their Victorian glory, whilst, externally, the collective grouping of Council House, Art Gallery and Clock Tower still forms the civic heart of the city.

Chamberlain Square still sports its Memorial Fountain to Joseph Chamberlain. Sadly, the adjoining Mason College, the former Public Library and the original Birmingham and Midland Institute have all vanished but amongst the many treasures housed in the new Library is a complete set of the books printed at the Kelmscott Press, many books illustrated by the Birmingham School, and the 'Shakespeare Room' by J. H. Chamberlain.

In many other corners of the city the impact of Pre-Raphaelitism on architecture is still very strong.

In the inner suburbs, the towers of J.H. Chamberlain's Board Schools still dominate the skyline, frequently vying with church spires by Julian Chatwin and the many other Birmingham architects. In street after street the influence of Ruskin can still be seen in multi-coloured brickwork, naturalistic carved capitals and pointed windows.

Birmingham's rich heritage of terracotta facades can be found on district libraries, public baths, adult institutes, pumping stations, the Law Courts, and schools.

Not far from the Council House, along Edmund Street, is the Municipal School of Art in Margaret Street. It has just been restored to its former pink-brick glory, and its sculptures, terracotta, tiles, ironwork, and stained glass can be admired once again, much as they were when Burne-Jones climbed its imposing entrance stairs in 1885. Internally, its impressive staircases and lofty top-lit studios, have been re-furbished to nourish a new generation of painting students.

Along Colmore Row, is the unexpected little Baroque gem of the church of Saint Philip, a true exotic, transplanted straight from Rome in 1714 by Thomas Archer. Unlike Wren, Archer had been to Rome and seen the latest architecture there. Now the rather unlikely seat of the Anglican Bishop of Birmingham, the church's second surprise is its set of magnificent stained glass windows by Edward Burne-Jones and William Morris. They must rank amongst the finest achievements of this amazing design partnership.

Across the Ringway is Pugin's most un-Roman, Roman Catholic Cathedral of Saint Chad. The interior is much altered, but the spirit of Pugin's Gothic is still tangible.

Along the Bristol Road, is the University of Birmingham, with its original campus by Aston Webb dominated by the pink-brick campanile of the

Chamberlain Clock Tower, and in the University's own art-deco art gallery – the Barber Institute – is Rossetti's sumptuous 'Blue Bower'.

Just beyond the University, is part of the social legacy of Pre-Raphaelitism. Bournville village, with a variety of housing types, churches, schools, and 'Ruskin Hall', is still far more humane and attractive than most of its successors in town-planning.

Between Moseley and Kings Heath, in Yew Tree Road, is 'Highbury' built by J. H. Chamberlain for Joseph Chamberlain. Now owned by the City, it too has been recently restored to its former glory. The interior overflows with the decorative delights of John Henry Chamberlain's Ruskinian imagination, whilst Millais's portrait of Joseph Chamberlain's third wife now hangs again in the Drawing Room.

Outside the city, just beyond Wolverhampton, is 'Wightwick Manor'. Owned by the National Trust, it has become a shrine to William Morris and the Pre-Raphaelites, and contains a large collection of their work.

One little pilgrimage remains. At the top of New Street, is the entrance to the present galleries of the Royal Birmingham Society of Artists. Just inside, the main staircase is flanked with the lists of the names of all the past members of the Society and those of the illustrious Victorian artists who have served as honorary Presidents since 1842. Among them you will find, picked out in gold lettering, the names of Millais, Holman Hunt, Burne-Jones, Leighton, Watts, Alma-Tadema, Herkomer, and Poynter. As you stand there, surely you can hear the clink of glasses, the rustle of long skirts, the cheery greetings of soirees, the bustle of vanishing days, the excitement of Private View days of long-gone Autumn Exhibitions … No?

It is true after all – Ars longa, vita brevis.

SELECT BIBLIOGRAPHY

ATTERBURY, P. and WAINWRIGHT, C.	Pugin: a Gothic Passion 1994
BAKER, C. ed.	Bibliography of British Book Illustrators 1860-1900 Birmingham 1978
BIDLAKE, W.H.	Birmingham as it might be in MUIRHEAD, J. Birmingham Institutions Birmingham 1911
BREEZE, G.	Arthur and Georgie Gaskin Birmingham 1981
BREEZE, G.	Joseph Southall Birmingham 1980
BRIGGS, A.	Social History of Birmingham since 1815 Victoria History of the County of Warwick Vol.VII p.223/4 Oxford 1964
BROOKS, M.	John Ruskin and Victorian Architecture 1989
BUNCE, J.T. and VINCE, C.A.	History of the Corporation of Birmingham Vols.I-III Birmingham 1902
BURNE-JONES, G.	Memorials of Edward Burne-Jones Vols.I-II. 1912
CANNADINE, D.	Lords and Landlords: The Aristocracy and the Towns 1774-1967 1980
CALLEN, A	Angel in the Studio 1979
CATTERSON-SMITH, R.	Edward Burne-Jones in MUIRHEAD, J.H. Nine Famous Birmingham Men Birmingham 1909
CHRISTIAN, J. Ed.	The Last Romantics: the Romantic Tradition in British Art:Burne-Jones to Spencer 1989
COMINO, M.	Gimson and the Barnsleys 1980
COOKE, E.T. and WEDDERBURN, A.	The Works of John Ruskin. Vols.I-XXXIX 1907
COOPER, J.	Victorian and Edwardian Furniture and Interiors 1987
CRANE, W.	Of the Decorative Illustration of Books Old and New 1896
CRAWFORD, A. Ed.	By Hammer and Hand: the Arts and Crafts in Birmingham Birmingham 1984
DALE, A.W.	The Life of R.W.Dale 1899

DAVIES, S.	By the Gains of Industry: Birmingham Museums and Art Gallery 1885-1985 Birmingham 1985
DENT, R.	Old and New Birmingham Vols.I-III Birmingham 1880
DENT, R.	The Making of Birmingham Birmingham 1894
FAIRCLOUGH, O. and LEARY, E.	Textiles by William Morris Birmingham 1981
GERE, C.	The Earthly Paradise 1969
HAMMOND, J.	Birmingham Places and Faces Vols.I-III Birmingham 1892
HENNOCK, E.P.	"Fit and Proper Persons": Ideal and Reality in Nineteenth Century Urban Government 1973
HILL, J. and MIDGLEY, W.	The History of the Royal Birmingham Society of Artists Birmingham 1928
HOLYOAK, J.	All about Victoria Square Birmingham 1989
HORNE, C.S.	R.W. Dale in MUIRHEAD, J.H. Nine Famous Birmingham Men Birmingham 1909
LAMBOURNE, L.	The Arts and Crafts Movement 1973
LANGFORD, J.A.	A Century of Birmingham Life 1867
LANGFORD, J.A.	Modern Birmingham and Its Institutions. Vols.I-II Birmingham. 1877
LINES, S.	A Few Incidents in the Life of Samuel Lines Senior written by Himself Birmingham 1862
LITTLE, B	Birmingham Buildings 1971
MARSH, J. and NUNN, P.G.	Women Artists and the Pre-Raphaelite Movement 1989
MOREAU, P-L.	Le Musee d'Art: Histoire Generale de l'art au XIXe Siecle Paris 1906
MORRIS, M.	Collected Works of William Morris 1915
POWELL, J.H.	Some Stray Notes on Art 1888
RALPH, J.	Harper's Monthly Magazine The Best-governed City in the World New York 1890
RODWAY, P. and SLINGSBY, L.	Philip Rodway and a Tale of Two Theatres Birmingham 1934
St.JOHNSTON, A.	The Magazine of Art – The Progress of Art in Birmingham 1887
SCOTT, E.	Ruskin's Guild of Saint George 1931
SHOWELL, W.	Dictionary of Birmingham Birmingham 1885

SIDEY, T.	Walter Langley 1852-1922 Birmingham 1984
SWIFT, J.	The Birmingham School of Art Archives 1880-1900 Birmingham 1989
TAYLOR, I.	The Edwardian Lady: the story of Edith Holden 1980
TAYLOR, I.	Victorian Sisters: the Macdonalds 1987
TIMMINS, S. Ed.	Handbook of Birmingham – (British Association Congress) Birmingham 1866
TIMMINS, S.	History of Warwickshire Birmingham 1889
TILSON, B. Ed.	Made in Birmingham: Design and Industry 1889-1989 Studley 1989
VINCENT, E.W.	Notable Pictures: the Contribution of the Public Picture Gallery Fund to the Birmingham Art Gallery Birmingham 1949
WALLIS, G.	British Art – Pictorial, Decorative and Industrial 1832-1882 Nottingham 1882
WATERHOUSE, R.	The Birmingham and Midland Institute Birmingham 1954
WILDMAN, S.	The Birmingham School Birmingham 1990
WILDMAN, S.	Visions of Love and Life Virginia 1995

SOURCES OF INFORMATION

Birmingham Reference Library: Local Studies Collection
1, 15, 18, 20, 30, 32, 34, 35, 44, 63, 64, 91, 99, 100.

Birmingham Art Gallery
ii, v, 13, 29, 68, 84, 88, 98, 105, 107, 113.

The Cathedral Church of Saint Philip, Birmingham
80, 81, 82, 83.

Birmingham Institute of Art and Design: Municipal School of Art Archive
75, 76, 77, 93, 106, 109.

Victoria and Albert Museum
62.

INDEX

I N D E X
Adam, Robert 11
Aitken, William Costen 5,31-4,38-9,50-4,73
Albert, Prince 33,35-6,39
Allport, Henry 12
Alma-Tadema, Lawrence 3,110,117
Archer, Thomas 78,116
'Aris's Gazette' 12
Armfield, Maxwell 104,107,110
Art Circle 86
Art Gallery Purchase Committee 73-4,79,87
'The Art Journal' 26,32,34,47-6,67,86,89,92
'The Art Union' 10,26
Ashbee, Charles Robert 108
Aston Hall 38-9,53,73
Atterbury, Paul 5
Attwood, Thomas 60
Aumonier, W. 96
Avery, Thomas 52

Baillie Scott, Mackay Hugh 58
Baker, George 52,65-7,71,74
Baker, Moseley 66
Baker, Oliver 100
Baker, Samuel 19
Ball, John Lancaster 102,110
Barber, Charles 12
Barber Institute 116
Barber, Joseph 9-11,14
Barber, Joseph Vincent 12
Barbican Gallery 4
Bardfield, Joseph 58,77
Barker, Robert 14
Barnsley, Edward 74
Barnsley, John 76
Barnsley, Sidney 74
Barry, Charles 31,78
Barry, Edward Middleton 35
Bastien-Lepage, Jules 69
Bateman, Charles 46,110
Beaucastle 65
Beauchamp, The Earl 108
Bell, Jacob 26
Bellefield 66
Bewdley 65,74
Bidlake, William Henry 108-10,112
Bingley Hall 78,84
Bingley House 33,53
Birch, Charles 37
Birket Foster, Miles 47
'The Birmingham Advertiser' 8
Birmingham Academy of Arts 8,12,15,22,24
Birmingham Art Gallery ii,4-5,29,46,48,53-4,61,73-
 4,85-8,111-3,115-6
Birmingham Board School 57,66

Birmingham Council House 1,59,73-4,102,116
'Birmingham Daily Post' 66,76
Birmingham and Edgbaston Debating Society 51
Birmingham Exhibition of Arts and Manufacturers
 32,33,36.
Birmingham Group 4,94,104,107-8,112-3,115
Birmingham Guild 96-7,108-9
Birmingham Improvement Scheme 58
'Birmingham Journal' 19,21,28-9,36,47
Birmingham Law Courts 116
Birmingham Public Library 1,53,59,73.
Birrmingham and Midland Counties Art Union 26
Birmingham and Midland Institute 35-6,53-
 4.59,66,70,74,76,91,116
'The Birmingham School' 5.
Birmingham School of artists 4-5,11,19,90,104-5,116
Birmingham School of Art 1,5,35-6,39,54,70,74-7,85-
 6,89-93,95-7,100-5,107, 110,116
Birmingham Society of Artists 1,5,7,11,18,24-7,35-
 7,39,46-8,50,54,67-8,70,78, 85,88,110,111,115,117
Birmingham Society of Arts 13,16,18-20,22,24-
 5,27,53,70
Birmingham Town Hall 1,39,53,59,70,112
Bladon 96
Bonheur, Rosa 37
'Book of Pictured Carols' 100
Bougereau, William Adolphe 67,85
Bournville 109,117
Bradford, The Earl of 48
Bradley, Gertrude 92,97
Breakespeare, William 67
Brett, John 54,76,87
'Brideshead Revisited' 108
Bright, John 64
British Association for the Advancement of Science
 32,53,84
Brockhampton, All Saints Church 102
Brockhurst, Gerald Leslie 4
Brown, Ford Madox, 26,46,87,89,112,114-5,OBC
Bryantspuddle 96
Buckland, Herbert Tudor 110
Budapest 101
Bunce, John Thackray 48,60,66,73,76-7,97,112
Bunce Kate 5,97,98,104
Bunce, Myra 97
Burne-Jones, Edward 3-5,41-2,56,64,71-2,78-86,89
 90,93,99,100,103,107,110,115-7
Burne-Jones, Georgiana 41,71,79,87
Burt, Charles Thomas 47
Buscot Park 84
'By Hammer and Hand: the Arts and Crafts Movement
 in Birmingham' 5,97

Cadbury, George 109
Calthorpe, The 4th Lord 58

Camm, Florence 97,115z
Canwell Hall 12, % 7. 6 o
Cardiff 73.
Carlyle, Thomas 14,18-9,55
Catterson-Smith, Robert 103-4,108
Central School of Arts and Crafts, London 102
Chamberlain, Arthur Bensley 86
Chamberlain, Austen 96
Chamberlain Clock Tower 116
Chamberlain, John Henry 5,35,41-6,50-68,7078,87,91,106,114,116-7
Chamberlain, Joseph 1,5,52,56-7,59-60,63-5,70,76,116-7
Chamberlain, Mary Endicott 64,85,117
Chamberlain Place 1,59-60,77,116
Chamberlain, Richard 71,73
Chantrey, Francis 26
Chatwin, Julius Alfred 78-9,110,116
Christchurch 1,13
Christchurch, New Zealand 46
Christian, John 4
Clarke, Thomas 40
Cole, Henry 33,35,99
Coleman, Edward 53
Collings, Jesse 52,71
Colmore, Cregoe 74
Constable, John 18,21
Cooper, Sidney 21
Cope, Charles 53
Cossins, Jethro Anstice 59,110
'The Country Diary of an Edwardian Lady' 97
Cox, David 9,21,26,37,46-7,53,85-6,89,115
Crawford, Alan 5,97
Crane, Walter 63,85,89,92,99-100,112
Creswick, Thomas 19
Crosskey, Henry William 51,76
Crouch, Joseph 110
Cuznor, Bernard 100
Cymric silverware 99

Dale, Robert William 51
'The Dart' 65,95
Davis, Frederick William 67
Dawson, George 1,50-1,53,59-60,103
Dawson Man 52,55-6,73
Debenham, Ernest 96
Debenham House 96
Delacroix, Eugene 29,37
Delaroche, Paul 37
Derby 33,73
Dickens, Charles 7,35
Dixon, Arthur Stansfield 96,110
Dixon, George 48,52,96
Dixon, Richard Watson 40
Dresser, Christopher 61
Drinkwater, John 108,116
Dudley Road School 66
Duranty, Albert 3-4
Dyce, William 24

Eadie, Kate 97
Eagle Insurance building 102
Easel Club 86

Eastlake, Charles Lock 46
Edgbaston 44-5,47,54,60,77,104
Edgbaston High School 95
Eld & Chamberlain 44
Elgin Marbles 11
Elkington, A.J. 23,73
Elkington, Frederick 54
Elvetham Hall 58
Ettington Park 58
Etty, William 37,47
Evans, Sebastian 79
Everitt, Alan 46,61
Everitt Cabinet 61
Everitt and Hill's Gallery, New St 37
Ewart, William 24,33
'The Examiner' 19

Faulkner, Charles 40-1
Faulkner, Kate 41
Faulkner, Lucy 41
Fine Art Society, London 104
Finnemore, John 67
Flaxman, John 10-1
Forbes, Stanhope 68
Fors Claviglera 65
Frampton, George 102
Fulford, William 40

Galton, Samuel 12
Gas Department 73
Gaskin, Arthur Joseph 4-5,74,90-2,99-100,104-5,108-10
Gaskin Georgina 4,92,97,99-100,108-9,114
Gere, Charles March 5,74,90-2,99,104,108-9
Gere, Margaret 97
Gimson, Edward 96
Gill, Eric 96
Gill, Macdonald 96
Gillot, Joseph 47
Glasgow 101
Glasgow Art-Union 37
Glasgow School of Art 101
Goddard, Henry 42
Grant, Francis 48
Great Exhibition 1851 10,33,37-9
The Grove 60-2,64,71,78
Grosvenor, Lettice 108
Guild of Saint George 65,67,74,77,104
Gunby, John 12

Handley-Read, Charles 61
Hardman, John 5,30-1,34,115
Hardman-Powell, John 5,85
Harper, Edward Samuel 99
'Harper's Magazine' 1
Harris, Edwin 67-8
Harris, William 52
Haselor, W.H. 100
Haydon, Benjamin 11
Henshaw, Frederick 25,47-8,86
Herbert Art Gallery, Coventry 10
Herkomer, Hubert 72,117
Hewell Grange 21

Highbury 60,63-4,117
Holden, Edith 97
Holden, Evelyn 97
Holden, Violet 97,104-5
Holder, John 98
Hollins, Peter 25-6,36,46,48,51,53-4,67
Hollins, William 25
Holy Grail tapestries 79,115
Hunt, William 47
Hunt, William Holman 3-4,7,28-9,36 7,39,47,64,72,
 86-7,89,110,115,117
Hutchinson, Henry 12,18
'The Illustrated London News' 33,87

Ingres, Jean-Auguste-Dominique 37
International Convention Centre 33

Jaffray, John 53,73
Johnston, Edward 102

Kelmscott Press 70,79,90-1,103,116
Kenrick, Byng 96
Kenrick, Cecily 61,95-6
Kenrick, Millicent 95-6
Kenrick, William 5,39-40,52,54-5,60-2,71-3,76,78,
 87-9,95-6,103,110,112
Kent, The Duchess of 21
King Edward's School 31,40,46

Landseer, Edwin 26,37,46
Langford, John Henry 44
Langley, Walter 4,68,86
'The Last of England' ii,46,89,114-5
Lawley, Robert 12
Lawrence, Richard 11
Lawrence, Thomas 10,18
Leeds 33,73
Leighton, Frederick 3,54,67,85,110,117
Lethaby, William Richard 102-4
Levetus, Celia 92,97
Liberty's 99
Lincoln School of Art 70
Lines, Samuel 9-14,19,25,46-7,51,54
Liverpool 54,67,73
Logsdail, William 75
Longworth 60
Luxembourg Palace, Paris 37
Lyttelton, The Lord 46

Macdonald, Georgiana - see Burne-Jones,
 Georgiana
Macdonald, Harry 40-1
Mackintosh, Charles Rennie 101
Maclise, Daniel 46
Madresfield Court 108-9
'The Magazine of Art' 85,92
Manchester 17,39,47,54,67,73,108,112
Marsh, Jan 97
Martin, William 46,53,76
Martineau, Robert Braithwaite 36
Mason College 1,59,116
Mason, Frederick 92
Mason, George Hemming 85

Mason, Josiah 59
Mathews Charles E. 66,102
Metchley Abbey 37
Meteyard, Sidney 104
Middlemore, John 87
Millais, John Everett 3-4,7,28,36-7,39,46-8,64,85-8,
 110,115,117
'Modern Painters' 7
Moore, Albert 85,87
Moore, Henry 63
De Morgan, William 96,115
Morris, Jane 41,71
Morris, May 102-3
Morris, William 4-5,30,40-2,45,56,63-4,70-2,78-83,
 87-93,095,97,99-100,103-4, 112,115-7
'Le Morte d'Arthur' 41
Mourey, Gabriel 92
Muckley, L. Fairfax 92
Murray, Charles Fairfax 89
'Le Musee D'Art:Histoire Generale de l'Art au XIXme
 Siecle' 92
Muthesius, Hermann 102

Napier-Clavering, Claude 96,107
National Association for the Advancement of Art
 and its Application to Industry 112
New, Edmund Hort 5,40,91-2,104-5
Newill, Mary 5,92,97,99-100
Newlyn 68-9,104,107,115
Newman, John Henry 37
'News from Nowhere' 90-1,104
Northampton Town Hall 58
Nottingham 72

Oddfellows Hall 37
'Of the Decorative Illustration of Books Old and New'
 92
Osler, Thomas Clarkson 54
Oxford 40-1,66,84,96,108

'The Pall Mall Gazette' 57
Panorama, New St. 13-5,18
Paris 2-3,37-8,47,85,92,101,104
Paxton, Joseph 33
Payne, Edith 99
Payne, Henry 90,92-3,102,106,108-9
Pevsner, Nikolaus 61,90
Pissarro, Camille 3,89,92
Pre-Raphaelite Exhibition 1891 ii,87,89,112
'The Pre-Raphaelite Journal' 7
Poynter, Edward 117
Pratt, Claude 67
Price, Cormell 40
Prior, Edward Schroeder 96
Public Picture Gallery Fund 54
Pugin, Augustus Welby Northmore 5,29-31,34,40,
 43,46,51,85,100,115-6

Queen's College, Paradise St 46
Queen's Hotel, New St 67

Radclyffe, William 12
Raimbach, David 35,54

Ralph, Julian 1
Ramsgate 31
Red House 41,45
Reynolds, Joshua 28
Ricardo, Halsey 96
Richmond, George 37
Richmond, William Blake 64,72,85
Rickman, Thomas 18
Roberts, William 12
Robinson, John Henry 37
Rossetti, Dante Gabriel 3-4,7,39,41,74,85-7,115-6
Rossetti, William Michael 7
Rothenstein, William 7,96,111,114
Rottingdean 71
Royal Academy of Arts 7,8,28,39,54,67,99,110
Royal Birmingham Society of Artists – see
 Birmingham Society of Artists
Royal College of Art 101-2
Royal Society of Arts 13,33
Rushbury, Henry 109
Ruskin, John 3-4,7,28,41-3,45,51,54-5,61,65-
 7,74,77,79,95,104,106,113,116
Ruskin Hall, Bournville 109,117
Ruskin Pottery 104
Ruskin Society 109
Ruskin Union 109
Russell, James 12
Ryland Louisa Ann 74

St.Chad's Cathedral 30-1,46,116
'Saint George' 109
St.George's, Edgbaston 46
St.Johnston, Alfred 1-2,77
St.Louis, Missouri 101
St.Martin's-in-the-Bullring 45
St.Mary's College, Oscott 30
St.Philip's Cathedral 1,13,15,45,78,80-3,89,116
Sandby, Paul 47
'The Seven Lamps of Architecture' 42
Shakespeare Library 53,116
Shaw, George Bernard 89
Shaw, Richard Norman 60
Shee, Martin Archer 25
Sheffield 73-4,100,113
Shenstone House, Ampton Road 44-5
Shirley, Evelyn Philip 58
Showell, William 39
Siddal, Elizabeth 41
Sleigh, Bernard 92,104
Smedley, Constance 97
Smith, Edwin 66
Society for the Protection of Ancient Buildings 71
Southall, Joseph Edward 4-5,74,92,99,104-
 5,108,110,113-5
Southbourne 64
South Kensington Museum 35,53,86,90,92,99
'The Stones of Venice' 42
Street, George Edmund 45,72
'The Studio' 93,99,107
Sultanganj 53
Swift, John 90

Tangye, George 73-4,87
Tangye, Richard 73-4,87
Taylor, Edward Richard 5,70,73,75,77,845,89,95,
 102-5,112
Taylor, William Howson 104,115
Taylor, Nicholas 61
Temple RowlS,18-20,25,35,37,78
Tennal Grange 96
Theatre Royal 13
Tocqueville, Alexis 21
Thomas, Inigo 92
Thomason, Yeoville 59
Thornton, Samuel 53
Timmins, Samuel 50,53,65-7,71,76
Tombs, Francis 12
Treglown, Ernest 102
Tudric pewterware 99
Turner, Joseph William Mallord 11,46-7
'Two Gentlemen of Verona' 29,89,115

Underwood's Fine Art Repository, Union Passage
 37

Vallance, Aymer 89-90,97
Van Gogh, Vincent 3
Venice 43,71,75,104
Victoria and Albert Museum 61,62Vernet~ Horace
 37
3 Victoria, Queen 21,33,39,48
Victorian Society 5
'Visions of Love and Life: Pre-Raphaelite Art from the
 Bormingham Collection' 5
Vittoria Street School of Jewellery and
 Silversmithing 103

Wainwright, Clive 5
Wainwright, William John 67,86,111
Walker, Eaton 46
Wallis, George 35,53-4,86
Wallis, Henry 46,87
Wallis, Whitworth 5,86-7,89,112,114
Waterhouse, Alfred 59,72
Watts, George Frederick 3,85-7,117
Waugh, Evelyn 108
Webb, Aston 116
Webb, Philip 41,45
Wedgwood, Josiah 11
Whall, Christopher 102
Whetstone 60,71
Whistler, James Abbott McNeill 67
Wightwick Manor 117
Wildman, Stephen 5
Wilkie, John 18
Wilkinson, Norman 104,110
Willmore, James Tibbetts 11
Winfield, R. W. 31-2,34
de Wint, Peter 47
Witton, Philip 12
Wolverhampton 73
'Women Artists and the Pre-Raphaelite Movement' 97
Woolner, Thomas 60